97854
Leach Library
Londonderry, NH 03053

JACQUES LIPCHITZ
THE FIRST CUBIST SCULPTOR

DISCARD

Leach Library
276 Mammoth Road
Londonderry, NH 03053

Adult Services 432-1132
Children's Services 432-1127

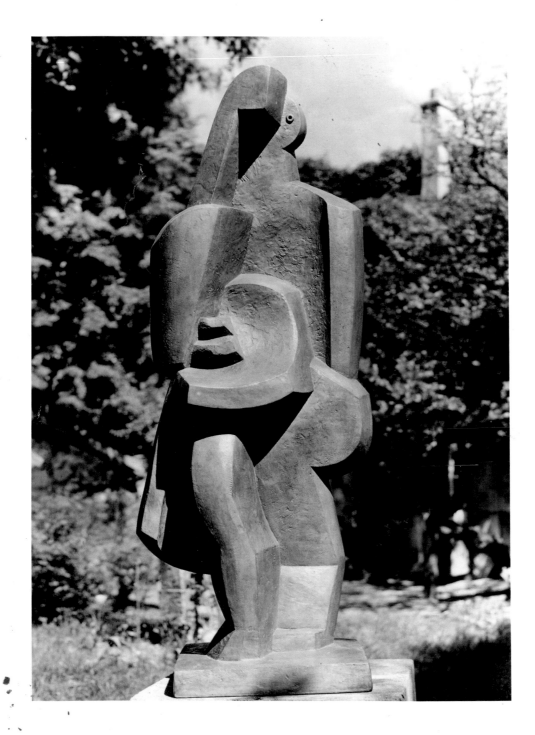

JACQUES LIPCHITZ
THE FIRST CUBIST SCULPTOR

Catherine Pütz

Paul Holberton publishing
IN ASSOCIATION WITH
Lund Humphries

730.9
PUT

03 June 17
B++
40.00 (28.00)

For Yulla Lipchitz and Colette Sicard

With especial thanks to David Fraser Jenkins, Chris Green, Gillian Merron, Hanno D. Mott, Derek Pullen, Joan Pütz, Melanie Roberts, Alfred Rolington, Susan and Winston Theriot, Prof. J.F. Yvars

The gift of plasters to the Courtauld Gallery is made by the Jacques and Yulla Lipchitz Foundation, who have also given generous permission for the reproduction of images from the artist's studio.

1. Lipchitz, Jacques, 1891-1973 – Criticism and interpretation.
2. Cubism – France.

First published in 2002 by
Paul Holberton Publishing
37 Snowsfields
London SE1 3SU
books@paul-holberton.demon.co.uk

in association with

Lund Humphries
Gower House
Croft Road
Aldershot
Hampshire GU11 3HR

and

131 Main Street
Burlington
VT 05401
USA

www.lundhumphries.com

Lund Humphries is part of
Ashgate Publishing

British Library Cataloguing-in-Publication Data
A catalogue record for this book is available from the British Library

ISBN 0 85331 860 3

All rights reserved. No part of this publication may be reproduced, stored in a retrieval system or transmitted in any form or by any means, electrical, mechanical or otherwise, without first seeking the permission of the copyright owners and the publishers.

Library of Congress Control Number: 2002100642

© Paul Holberton publishing
Text © 2002 Catherine Pütz
Photographs: Works by Lipchitz
© 2002 The Estate of Jacques Lipchitz, represented by Marlborough Gallery, New York.
Work by Archipenko © ARS, NY and DACS, London, 2002.
Works by Picasso © Succession Picasso/DACS, London, 2002.
Work by David Smith © Estate of David Smith/VAGA, New York/DACS, London, 2002.

FRONTISPIECE: Jacques Lipchitz, *Bather*, 1923–25 Bronze, edition of 7, 196.9 cm high Marlborough Gallery Inc. (also: Dallas Museum of Art; Wight Art Gallery, U.C.L.A.; M.I.T. List Visual Art Center; St Louis Art Museum; Sheldon Memorial Art Gallery, University of Nebraska; Norton Simon Museum, Pasadena; Herbert F. Johnson Museum of Art, Cornell University)

COVER: Jacques Lipchitz at work in Italy on a plaster for *Peace on Earth*, photographed September 1967

FRONT AND REAR FLAP: Jacques Lipchitz, *Girl with braid*, 1914 Bronze, edition of 7, 83.8 cm high (The Barnes Foundation, Merion, Pennsylvania; Philadelphia Museum of Art)

Produced by Paul Holberton publishing

Designed by Philip Lewis

Printed in Italy by Grafiche Milani

Contents

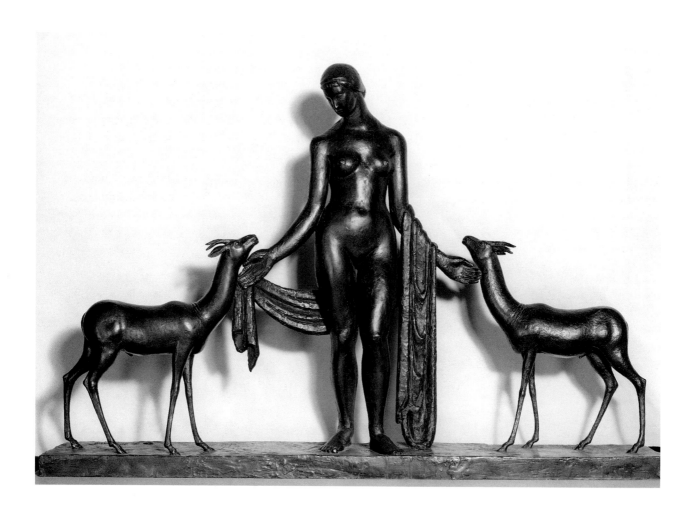

Jacques Lipchitz:
The First Cubist Sculptor?

"And so, Rodin; Maillol; Bourdelle; Lehmbruck; Picasso, who had sculpted his Head of a Woman in 1910; Brancusi; Nadelmann; Archipenko; Matisse, who was sculpting quite brilliantly à la Rodin; Modigliani, who was africanizing; Boccioni and Duchamps Villon; Epstein in England. There you have it – the condition of modern European sculpture as it was at the start of 1913."[1]

1. Jacques Lipchitz
Woman and gazelles, 1911–12
Bronze, edition of 7
116.8 cm high
Marlborough Gallery Inc.

With this kaleidoscopic array of names and styles, Jacques Lipchitz opened a personal account of the beginnings of cubist sculpture in a letter of 1947 to Daniel-Henry Kahnweiler, the great cubist dealer. How strange for him to offer so rudimentary a lesson to one who would surely have known this territory intimately. Yet Lipchitz could see that the nature and origins of avant-garde sculpture had never been adequately extricated from the history of painting. Even Kahnweiler, in his 1946 book on the sculptor's painter-friend Juan Gris (1887–1927), had, Lipchitz complained, mistakenly suggested that cubist sculpture had merely been an extension of cubist painting. Just so today Cubism is generally considered an exclusively painterly concern. In fact, it not only attracted the interest of sculptors but, most significantly, many of the movement's principles were worked out more literally and, one could argue, more successfully in sculpture than they ever could have been in painting.

Of those sculptors who attempted to understand and absorb its language, Jacques Lipchitz more than any other became a lifelong convert to Cubism, and it is for adopting this new aesthetic so fundamentally that he can be considered the 'first', that is, the original cubist sculptor. He continued to produce 'real' sculpture, working with traditional methods, while expressing a radical shift in the proposed relation between the art-object and the world it inhabits. He was certainly seen by his contemporaries as the most prominent cubist sculptor and as the sculptor who had given Cubism a human face. So it was, as Lipchitz himself recalled, that in Paris he was nicknamed "the optimistic cubist".[2] Lipchitz would never have claimed for himself the title of first cubist sculptor, since he recognized the extent to which avant-garde

sculptors assisted each other in grappling with cubist ideas, amongst them, for example, the Hungarian Jószef Csáky (1888–1971) and the Russian Ossip Zadkine (1890–1967), also working in Paris. Other sculptors, such as Raymond Duchamp-Villon (1876–1918), experimented before him with new approaches to sculpture that were related to cubist principles. In his proximity to the cubist painters the sculptor Henri Laurens (1885–1954) was also equal in status with Lipchitz. However, if history were to elect an individual who consistently worked with sculpture's animated, three-dimensional space to achieve, in intention and effect, the equivalent of Picasso's and Braque's cascading perspectives and stripped-down form during the key 1909–1914 period, that person would be Jacques Lipchitz.

The year 1913 was an appropriate moment from which to take a perspective of early avant-garde sculpture. It was the year Lipchitz had been introduced to Picasso by the artist Diego Rivera, and (as he later claimed) had reacted strongly against the way Picasso was applying paint to his three-dimensional constructions.[3] It was also the year that Lipchitz received critical acclaim for the first time since emigrating to Paris from Lithuania in 1909, for his *Woman and gazelles* (fig. 1) at the prestigious Salon d'Automne. For the other sculptor principally associated with Cubism, Laurens, who was born in Paris and had trained, according to the tradition of French artisans, in a decorator's studio, 1913 was equally significant. Laurens showed for the first time at the Salon des Indépendants that year, and was by then established in Montmartre. He was close to Braque and through him experienced the initial 'shock' of Cubism that would set him in the new direction of constructed sculpture. Picasso's 1912 sheet-metal *Guitar* (fig. 2) had, within a close artistic circle, made a considerable impact for its unconventional use of crude materials and its audacious *trompe-l'oeil*. Meanwhile the 1913 summer exhibition of the sculpture of Umberto Boccioni (1882–1916) at the Galerie de la Boëtie suggested, to Lipchitz, the first plausible method of exploring cubist theory in sculpture – by the 'solidification' of space, that is, the incorporation of the space around an object into the artistic construction.

Taking these as key events marking the convergence of modernist sculpture and the existing cubist aesthetic, one can be much more specific than Lipchitz was in writing to Kahnweiler about the form that early cubist sculpture was set to take. As Lipchitz's list suggests, the field of investigation

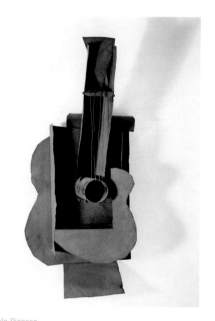

2. Pablo Picasso
Guitar, 1912–13 high
Sheet metal and wire
77.5 × 35 × 19.3 cm
The Museum of Modern Art, New York.
Gift of the artist 1971

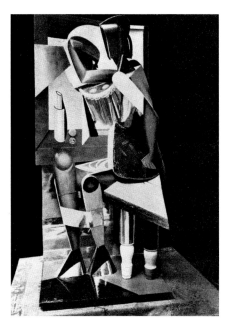

3. Alexander Archipenko
Woman in front of a mirror, 1914
Glass, wood, metal and mirror
Approx. 180 cm high
Destroyed

of pre-war European sculpture was certainly wide. Aristide Maillol (1861–1944) and sculptor-painters like André Derain and Henri Matisse worked generally with a still intact, unified sculptural block, but were attempting something quite new in the way they explored the essential independence of sculptural form, its ability to communicate as 'object', separate from whatever it ostensibly 'represented'. The work of Émile-Antoine Bourdelle, Wilhelm Lehmbruck and Jacob Epstein, highly individualistic and emotionally charged, explored the possibility of expressing very private themes in public contexts. None of these, however, could be said to convey the dislocations of Cubism, its play of equivalences, its teasing use of caricature, or its blatant challenge to conventional expectations.

Amongst artists, the earliest sculptural equivalents to cubist painting were considered to be Boccioni's 1912 *Development of a bottle in space*, Raymond Duchamp-Villon's 1914 *Horse* and Alexander Archipenko's 1914 *Woman in front of a mirror*, an assemblage of glass, painted wood, metal and a mirror fragment (fig. 3). This last work in particular and Picasso's assemblages of 1912–15 demonstrate that new methods of constructed sculpture were crucially about the provocative effect of substitution – substitution of the expected material and the expected notation, or sign, with another. They were also about the relationship between signs, the dramatic effects of juxtaposition. Frequently the planar dissections used in cubist painting to create jarring juxtapositions were achieved even more directly and effectively by sculptors in the way they exposed the skeletal architectures, the sculpture's framework, which they would previously have felt obliged to fill out with a suggestion of mass. Before the First World War, as we can see, Cubism was, for sculpture, inextricably equated with a process of evident construction, with metaphors of the machine that suggested movement, simultaneity and interconnectivity, a patterning of heterogeneous parts working in unexpected harmony.

A supreme draughtsman, the young French sculptor Henri Gaudier-Brzeska (1891–1915) provides a pertinent example of the way early avant-garde sculpture might suggest the skeletal frame without necessarily abandoning mass altogether. His 1914 *Redstone dancer* is 'geometric' in its pyramidal construction, developed from a 1913 ink sketch of tumbling ovoids and triangles (figs. 4 and 5). But the dynamic presence of the work is due to a purely sculptural

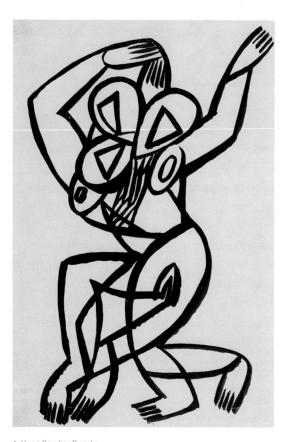

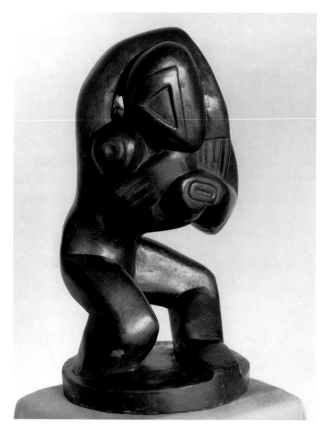

4. Henri Gaudier-Brzeska
Study for *Redstone dancer*, ca. 1913–14
Brush and ink on paper
38.5 × 25 cm
Musée National d'Art Moderne,
Centre Georges Pompidou, Paris

5. Henri Gaudier-Brzeska
Redstone dancer, 1914
Red Mansfield stone, polished and waxed
43 cm high
Tate, London

balancing of form around a central, twisting axis, and to the sheer density of the finely modulated stone. The case of Gaudier suggests an important point. The geometrical devices brought into sharp focus by the cubist painters were already a traditional part of the sculptor's planning process. In Paris, as elsewhere, architectural planning remained a central part of a sculptor's academic training. Picasso's sculptural constructions were driven by a fascination with structure which sculptors had no need to emulate: it was already part of their craft, intuitively apprehended as much as learnt. More important was the impetus cubist painting gave to sculpture before the First World War towards developing an infinitely variable language, one that could suggest a more complex experience of the world than could traditional artistic practices.

The work of talented young sculptors not directly associated with Cubism, like Gaudier, who lived in Britain in 1907–09 and 1911–14, demonstrates just how widespread was the quest for a new, properly sculptural language. Across Europe an emerging generation of sculptors was seeking to inject a sense of organic dynamism into their work, connecting as directly as possible with the emotions. To achieve this, they broke down their existing syntax and emphasized the individual units of expression, using light and space as potent elements to animate form and to hint at the presence of some all-pervasive, inexpressible, underlying mystery. That these formal devices could be applied in highly equivocal and unexpected ways was primarily what cubist painting suggested to them. As the painter-writer Maurice Denis noted in 1915, "Whether it had to do with questions of solid and void or of stasis and movement, which had seemed opposites and were being shown as fundamentally reciprocal, these were the issues being raised during the period 1907 to 1911".[4]

While artists were finding widely diverse ways of exploring these uncharted territories, in the press and for a larger public the label 'cubist' was initially applied to sculpture with some uncertainty, merely as a term to denote 'avant-garde', and referring to sculptors working in varying styles, from Constantin Brancusi (1876–1957) to Elie Nadelman (1882–1946) and Duchamp-Villon.[5] It is apparent from early reviews that avant-garde sculpture suffered in the eyes of the critics through having no obvious, charismatic 'leader', like Picasso, so that sculptural innovation was consistently, if wrongly, perceived as following rather mutely in the path of painters. If not a 'leader', the most controversial of the European avant-garde sculptors before the war was seen to be Alexander Archipenko (1887–1964). It is he who prompted the first public use of the term 'cubist sculpture', which was in 1911 – not surprisingly, by that great champion of new movements Guillaume Apollinaire.[6] The first exhibition to provoke discussion of 'cubist sculpture' in Paris also took place that year, organized by the Duchamp brothers at the Galerie de l'Art Ancien et de l'Art Contemporain. It included works by Archipenko, Duchamp-Villon and Nadelman. One critic, Gustave Kahn, noted sceptically, ". . . sculptural Cubism should emphasize the angles and profiles and worry less about stylizing volumes". Another, André Salmon, seemed pleasantly surprised that sculptors had taken on Cubism at all:

"Archipenko is Russian and, an even more unusual fact, is pursuing Cubism. Few sculptors at present are following this path, but not for much longer . . . we should expect and hope to see all modern sculptors embracing Cubism."[7]

Indeed by 1912 a number of sculptors from across Europe, who had visited Paris and experienced Cubism first hand, were able to explore some of its implications at a distance, against the background of their own experience and traditions. Sculptors working in Prague, notably Otto Gutfreund (1889–1927), who had studied in Paris from 1909 to 1910, also benefited from the activities of the Czechoslovakian collector Dr Vincenc Kramár, a good friend of Kahnweiler's, who built up one of the most important pre-war collections of cubist art. An exhibition of his collection in May 1913 at the Mánes Society in Prague included Picasso's 1909 *Head of a woman (Fernande)* (fig. 6), and a further exhibition in 1914 included works by Archipenko, Brancusi and Duchamp-Villon. In response to the 1913 exhibition, Gutfreund contributed a critique to a Prague journal raising questions crucial to Lipchitz's earliest engagement with Cubism: "Picasso breaks up the surface of the object and destroys its organic cohesion. He deliberately sacrifices the object's integrity for the sake of his system of separate but interconnected segments, used to construct a new organism But it seems to me that sculpture should retain some connection between the structures of the natural world and the forms of the artist's work."[8] Such were exactly the issues being discussed in Britain by Gaudier-Brzeska and Ezra Pound between 1911 and 1913.

In Paris meanwhile, the attention of public and critics alike was focused above all on the Salons. The place for up-and-coming young sculptors to show was the Salon d'Automne. Here, by the time of the 1913 Salon, it appeared to be Duchamp-Villon to whom the flame of avant-garde sculpture had passed. He had already exhibited no less than twenty-three works at the first major cubist group exhibition, *La Section d'Or* in 1912 at the Galerie de la Boëtie, and now critics were finding his sculpture increasingly startling. An explanation for their surprise at the sight of a work such as the 1913 relief *The lovers* (fig. 7) is offered by a remark made many years later by his brother, Jacques Villon. Describing the nature of Duchamp-Villon's experimentation before the sculptor's career was brutally cut short during the war by typhoid, Villon commented in 1954: "Sculpture is forsaking its function as document so as to give full rein to the original, creative function".[9]

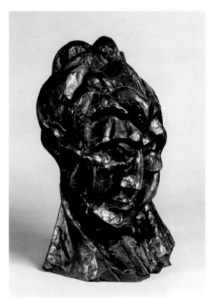

6. Pablo Picasso
Head of a woman (Fernande), 1909
Bronze
41.9 × 26.1 × 26.7 cm
Art Gallery of Ontario, Toronto

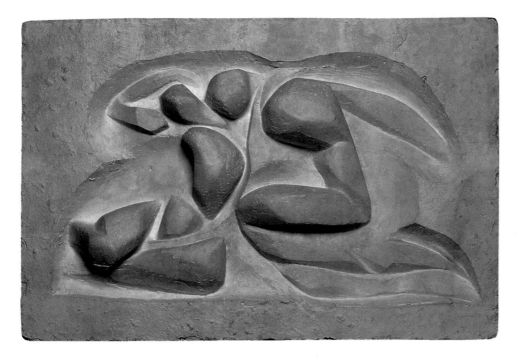

7. Raymond Duchamp-Villon
The lovers, 1912
Plaster relief
63 × 100 × 11 cm
Musée National d'Art Moderne,
Centre Georges Pompidou, Paris
(also: Philadeliphia Museum of Art;
Museum of Modern Art, New York)

Young sculptors like Duchamp-Villon were striving for emotional and creative authenticity with an intensity that critics perceived as destabilizing. Questioning the sculptor's putative task of creating definitive and durable monuments to 'history', they focused rather on internal truths and looked to those as a common source of enlightenment, a way to modern social cohesion. They celebrated the power of the individual mind and its inventive genius, an imperative that became even more keenly focused after the war. For many sculptors the quest for authenticity involved grappling in a more dynamic and intimate way with their material, attempting, in Duchamp-Villon's words, to follow the "logic" of their materials, as the sculptor Aristide Maillol, for example, had begun to do before him. If, for the avant-garde painter, the material would continue to be the support for the idea, for the avant-garde sculptor the very materiality of their work now needed to communicate its essential message. The new belief – that sculpture could convey emotions and ideas without the need for hyperbole – sought its expression not through conventional symbols, but, as we shall see, through a radical review of the way traditional sculptural materials were used, and through the evolution of an abbreviated language of personal metaphor. This clearly brought with it major implications for the act of viewing as well as for that of making sculpture.

The first of Lipchitz's sculptures to take up and develop these radical new ideas dates from after the outbreak of the Great War. Lipchitz was on holiday in Spain when war was declared. Although his sculpture from immediately before the trip does show an attempt at a new organization of form based on a dissecting of the figure and counterbalancing of opposed parts, it is his 1914 *Sailor and guitar* (fig. 8), inspired by a Spanish scene, which is the first piece to arrive at an integrated expression of the ideas he had encountered in Paris. Lipchitz later in life described this sculpture as "building up a figure from abstract forms rather than geometricizing a realistic figure",[10] which approximated in his mind to the synthetic processes of cubist painting. The work is less elaborate in its detailing than his previous figure studies but is much more complex structurally. With a corkscrew twist, its interlinking sections lead our eye around the figure, and as the light catches the different planes the forms seem to follow a steady rotating movement. Despite the stylized angularity of its parts, the sculpture is not detached from human reality, quite the contrary. It conveys the general idea of 'sailor' and the particular experience of a jaunty, rather boastful character, who winks as he confidently swings his hips, well before we begin to look at the highly abstracted parts from which that figure is made. Lipchitz takes a readily familiar everyday reality – a sailor in uniform – just as the cubist painters had selected simple still lives and street-café scenes and then given them what was felt as being a higher level of generality. His sailor becomes the very symbol of masculinity as also of the musician-cum-charmer and troubadour. Lipchitz meanwhile creates a new vocabulary of form – allowing us to read a flat disc, for example, as a hip – which is so well sustained and unified that the work can be read without any sense of rupture, even while revolutionizing the way we read it.

Within a year Lipchitz had taken this a step further, using references to the figurative but not dependent on them. The sculpture in question was a striking bronze *Head* (fig. 9), the most integrated expression to date of a refined sculptural language that could now truly be called 'cubist' for the way it clarified and distilled the new sculptural trends. It is with this that Lipchitz became the first truly cubist sculptor, and with this and the 1914 *Sailor and guitar* that Lipchitz established a way forward for cubist sculpture that could be popular in its immediate contemporary appeal and still acknowledge and carry further the centuries-old practice of casting small

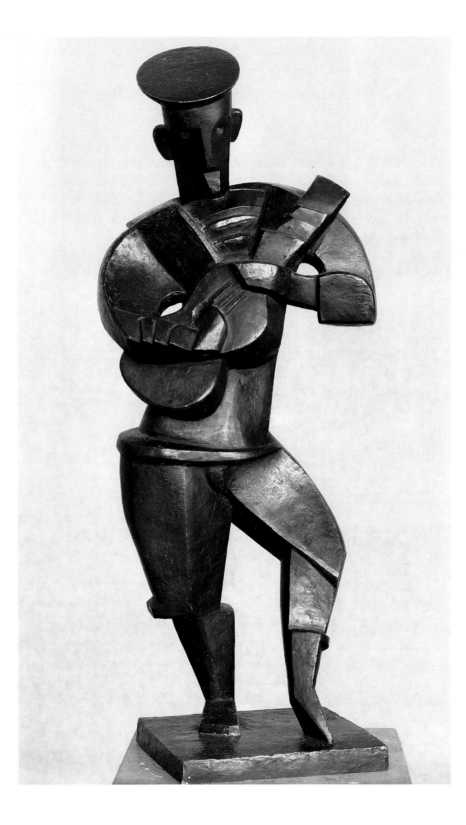

8. Jacques Lipchitz
Sailor and guitar, 1914
Bronze, edition of 7
76.2 cm high
Albright-Knox Art Gallery, Buffalo
(also: The Barnes Foundation, Merion,
Pennsylvania; Musée National d'Art
Moderne, Centre Georges Pompidou,
Paris; Philadelphia Museum of Art;
St Louis Art Museum, Missouri)

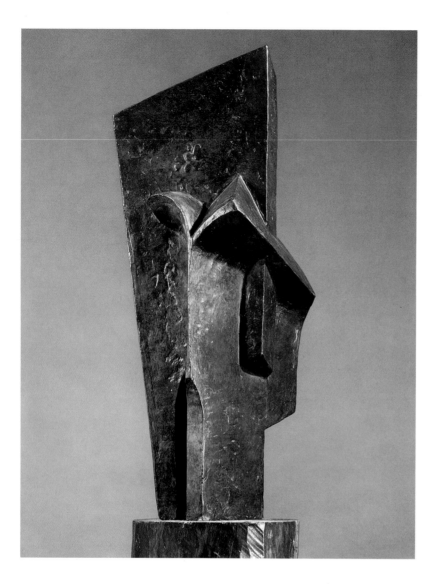

9. Jacques Lipchitz
Head, 1915
Bronze, edition of 7
76.8 cm high
Tate, London (also: Hirshhorn Museum
and Sculpture Garden, Smithsonian Institution,
Washington, D.C.)

bronzes. The *Head* works with its traditional medium of bronze, using the textures and illuminated surfaces of the metal to contribute to its meaning, unlike the bronze version of Picasso's 1909 *Head of a woman (Fernande)*, in which the medium has little contribution to make to our reading of the piece. Bearing in mind Gutfreund's comment on Picasso's sculpture, we can see that, in contrast, Lipchitz's *Head* is a complete, 'organic' entity, seamlessly integrating material and content. It recalls human features and the proportions of a face, but in its expressiveness it is independent from the known, human world. It is a new object unlike any we have previously seen. In this, and in its measured formal discipline, it offers a text book exposition of cubist principles.

The key to its new language is that its meanings accumulate for the viewer by a process of subconscious association – it works, in other words, metaphorically. The associative readings of its parts add together to form an overall impression that will vary depending on the individual viewer. It can be read as some sort of building, also as the stern gathering of brows in a male portrait; while a side view reveals a sprouting form like a budding flower clinging to a blistered wall-face. No one reading is necessarily deliberate on the part of the artist, and, by the same token, there can be no one 'right' reading. Here is the deliberately polyphonic nature of Cubism, seeking to emulate the tautness and resonance of the purest of musical forms. The work appears not as a random assemblage, but communicates through organically related parts, none of which could function without the other. While his friend Laurens explored related ideas in collage and polychromed assemblages, which remained painterly in their effect, Lipchitz was the first to achieve the successful translation of a complex cubist idiom into three dimensions using conventional sculptural means.

Nevertheless, that same year, 1915, Lipchitz soon began to doubt the direction he was following, fearing that he was losing some necessary link with objective reality. After considerable anxiety and struggle, he regained the confidence to launch himself into a meteoric career. To understand how he did so one needs to view his work in its broader context and with an eye to his own character and background.

1. Jacques Lipchitz, letter to D.-H. Kahnweiler dated 27.5.47 (orthography as in the original text); Tate Lipchitz Archive, File A17.
2. Lipchitz in conversation with Deborah Stott, Pietrasanta, Italy, 14 July 1969; transcript Tate Archive.
3. Jacques Lipchitz with H.H. Arnason, *My Life in Sculpture*, London 1972, p. 7.
4. Cited by Pierre Francastel, *Les Sculpteurs célèbres*, Paris 1954, p. 313 (original source unidentified).
5. References to early definitions of cubist sculpture are drawn from Martine Franck's undated (but after the mid 1960s) *Sculpture et Cubisme: 1907–1915.*

Mémoire préparé pour l'École du Louvre, supervised by Jean Cassou and Bernard Dorival, Paris.
6. Guillaume Apollinaire, preface for the summer 1911 Brussels exhibition catalogue of the Salon de la Société des Artistes Indépendants.
7. Gustave Kahn, *Mercure de France* (Paris), 16 December 1911, p. 846; André Salmon, *Paris Journal*, 14 December 1911.
8. Otto Gutfreund, *Plocha a Prostor* (Prague), no. 11, 1913.
9. Jacques Villon, in Francastel 1954, pp. 306–07.
10. Lipchitz with Arnason 1972, p. 18.

II The Optimistic Cubist

10. Jacques Lipchitz
(centre) *Detachable figure: Dancer*, 1915
Ebony and oak, mounted on wood
98.1 cm high
Original exhibition photograph

Of all the impressions retained from his upbringing as a Lithuanian within a persecuted Jewish community, the most significant at severe moments of crisis in Lipchitz's career was the impact that his father's professional convictions had made on him as a young man. Lipchitz's father had been a prominent building contractor, effectively an architect, who believed, as Lipchitz recounted, in the potentially dynamic social contribution of architecture that was successfully conceived in harmony with its environment. During the 1920s Lipchitz grew close to the French architect Le Corbusier (1887–1965), who was to design a studio for him in Boulogne-sur-Seine, and they would spend hours arguing in Paris cafés about the relative merits of sculpture and architecture. Lipchitz attempted to convince his friend that it was sculpture, which implicitly measured itself by the scale of the human figure, that gave architecture its necessary human dimension.[1] In his own work, Lipchitz strove from the first to be directed by architectural principles. He aimed to produce sculpture with a clarity and balance of structure as finely meshed as the skeleton of a cathedral (to use an image of which the avant-garde was especially fond between the wars). In its effect he wanted his work to emulate the ease of a natural organism moving through space. It is this combining of tight structural discipline with the drive to make an art that relates to the dynamism of living organisms which marks out Lipchitz's particular 'brand' of Cubism. During his years in Paris, before fleeing the German occupation in 1941 and being obliged to start a new career in America, Lipchitz refined the nature of this balance, never abandoning formal cubist control, and determined to prove that, in an age of increasing social and racial tension, Cubism continued to be well placed to address the most pressing contemporary human issues.

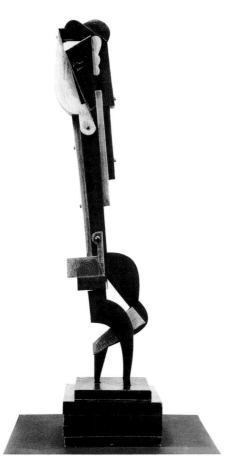

11. Jacques Lipchitz
Detachable figure: Dancer, 1915
Ebony and oak (unique)
98.1 cm high
Cleveland Museum of Art

To the convictions brought with him when he arrived in Paris in 1909, Lipchitz added the lessons learnt from his activities as an avid and soon highly accomplished collector and connoisseur of works of art. As his friend the art critic Waldemar George (1893–1970) affirmed in an outline biography of the sculptor (see pp. 119ff.), Lipchitz started collecting from the moment he arrived in Paris, educating himself through the displays at the Louvre, where he took particular note of the arts that were then considered 'primitive' – from archaic Greece, ancient Egypt, the Roman empire, and the French Romanesque and early Gothic. In addition he was following fellow artists such as Picasso and Derain in their passion for the sculptures from Africa and Oceania that were flooding Parisian flea markets.[2] Lipchitz acquired such a degree of expertise in assessing the quality and value of these objects that his advice was often sought by other artists and collectors. The respect he earned enabled him to secure important new clients and gave him access throughout his life to major collectors and dealers. More fundamentally, his 'dialogue' with his private collection provided constant inspiration for his own work. It is clear from the constructed sculpture he produced in 1915, as he considered the relationship of cubist forms with the workings of machinery, that he was also looking at the efficiency with which ancient tools and utilitarian objects were crafted, and at the way African sculpture used colour to heighten its effectiveness. The *Detachable figure: Dancer*, for example (figs.10 and 11), is finely pieced together in ebony and oak, painstakingly jointed and riveted, recalling the structure and detailing of an ancient Chinese crossbow in Lipchitz's collection. For his *Detachable figure: Seated musician* (fig. 12) he used a startling red paint over half of the geometricized head to dramatic effect, just as he had observed in African sculpture. Interestingly, according to his own account, Lipchitz's first encounter with Picasso involved an intense discussion about the uses of polychromy in contemporary art. At Picasso's studio Lipchitz spotted one of the artist's painted assemblages of found objects and commented that the colour was somewhat redundant, not used to enhance the psychological impact of the work as it would be in African art. While initially piqued by this observation, Picasso recognized Lipchitz's astuteness. He sought the sculptor out again the next day and there started a life-long friendship, not without fracas, as at its beginnings, but certainly characterized by mutual respect, curiosity and influence.

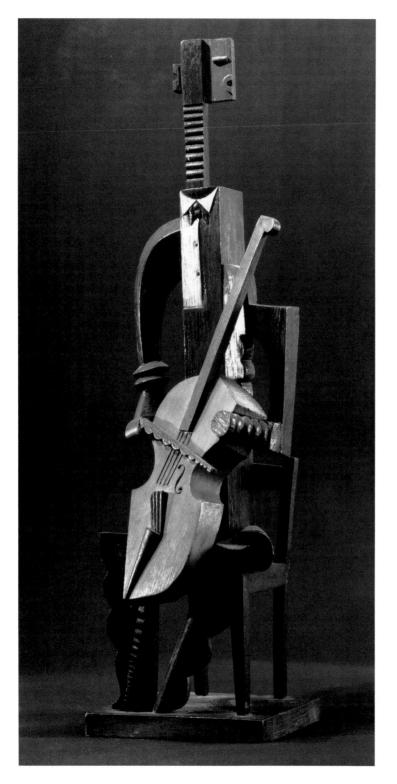

12. Jacques Lipchitz
Detachable figure: Seated musician, 1916
Painted wood
49.5 cm high
Collection of Mrs Yulla Lipchitz, New York

13. Jacques Lipchitz
Sculpture, 1915
Bronze
93.7 cm high
Marlborough Gallery Inc.

Lipchitz made a number of his jointed, "detachable" or, as he called them, "demountable" constructions, testing the degree to which sculpture could function like any practical everyday object, and look as if it could be assembled or taken apart at will, with interchangeable, abstract sections. His sculptures remained figurative, but only just. Lipchitz was reaching a point where, as we can see with the 1915 *Sculpture* (fig. 13), any reference to the human form was overwhelmed by the architectural design. The result in this particular case is a work that seems overly theoretical, like a mathematical sign. Lipchitz in this period had claimed that he wanted to make art that was as "pure as a crystal", ridding sculpture of centuries of bombast and extravagant symbolism. He soon realised that his evolving vision had little to do with the humanity he intended his work to celebrate, and the crisis of confidence he suffered was acute. However, he remembered his father's advice to construct every project from the base upwards, starting with the core building-blocks suggested by the forms of the natural world, and the work that followed during 1916–17 counts as the most elegant and accomplished of his 'high cubist' period.

Just as Braque, Picasso, and Juan Gris, to whom Lipchitz was especially close, grounded their investigations in an analysis not only of Cézanne's technique but also of the iconography of the great French masters such as Ingres and Poussin, so would Lipchitz when in 1917 he produced a classic series of *Bathers*, the most accomplished being *Bather III* (fig. 14). These take as their source the French artistic traditions he most admired, which included from the eighteenth century Étienne Falconet's sculpture, such as his marble *Bather* (1757), and Antoine Watteau's *Judgement of Paris* (ca. 1718), which Lipchitz knew well from the Louvre. It was the light and warmth of Watteau's canvases that captivated the sculptor throughout his life, the impression of a humanity which could transcend corporeal reality, even if only in poetry, pantomime and play.

In *Bather III* Lipchitz communicated these feelings metaphorically by suggesting rippling flesh with rhythmical undulations of form that convey a sense of grace and exuberance. Viewed individually, the segments that build the figure are more 'abstract' than those Lipchitz had formed previously, resembling the cones and cylinders of Fernand Léger's monumental post-war paintings, while conveying a sense of steady, focused movement. Their

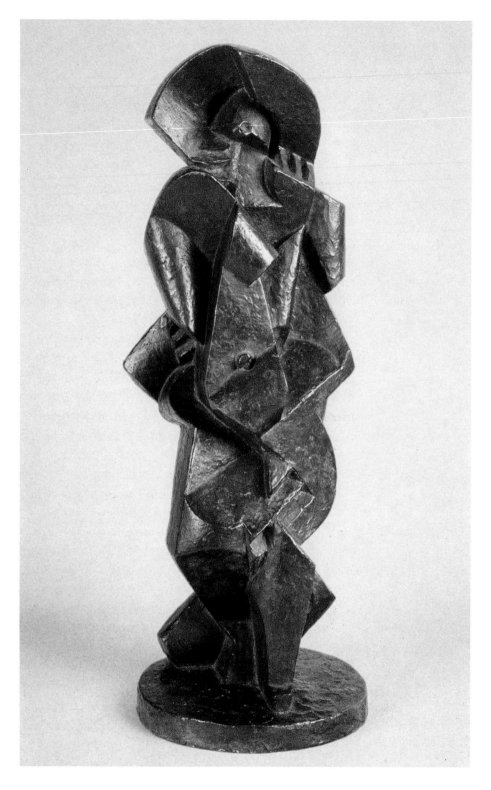

14. Jacques Lipchitz
Bather III, 1917
Bronze
71.8 cm high
Art Gallery of Ontario, Toronto
(also: Norton Simon Museum,
Pasadena, California)

sequence is so carefully balanced, linked by a continuous train of light delineating a bending knee or a raised arm, that our overall impression is of a classically figurative rather than a modernist image. For Lipchitz, the 'humanity' of this sculpture came from its method of construction, not its subject-matter. Cubism, as Lipchitz saw and practised it, was envisaged as the most 'human' of art forms, a celebration of mankind's creativity, engaging the active involvement of the viewer's imagination through surprise and metaphor.

Like many in his circle, both during and after the Great War, Lipchitz fêted the liberating effects of imaginative play by embracing the world of Italian street theatre, the Commedia dell'Arte, producing a host of its traditionally masked characters – Pierrots, Harlequins and a panoply of musicians – like those that wandered through the scenes of his friend Max Jacob's poetry (his 1921 *Le Bal masqué*, for example) or Erik Satie's musical score and Picasso's stage-setting for the ballet *Parade* (1917). Just as Picasso's *Harlequin* canvas of 1915 (fig. 15) had combined highly stylized front and side views of the character's head, constructing the figure as though from a series of cardboard cut-outs, and suggesting constant shifts in role and costume by using bold colour to confuse the layering effect of the forms, so in Lipchitz's *Harlequin with accordion* of 1919 (fig. 16) the face is dissected to suggest a partially veiled personality. Lipchitz's figure takes on the animated concertina patterning of the instrument it plays, with sharply cut, tumbling sections that create a bold play of light and shadow. Lipchitz could also suggest shifting meanings and identities with great subtlety in the format of bas-relief. Through a series in 1918 of musically themed reliefs, such as the *Still life* (fig. 17) which would eventually take its place on the façade of the Barnes Foundation, Merion, Pennsylvania, Lipchitz explored increasingly free-form rhyme and dissonance within a geometrically balanced and controlled space. The forms we see here of the fruit, clarinet, mandolin and sheet-music dissolve and collide; two frets hover in a shallow space, a few empty bars or a free-floating sound-hole suggesting a wave of imaginary sound and movement.

By the time Lipchitz met the formidable collector Dr Albert C. Barnes, in 1922, his work was exploring several different directions, as he developed the more fluid, suggestive language emerging in the 1918 reliefs, and responded to new commissions that came to him as the Paris art markets thrived in the

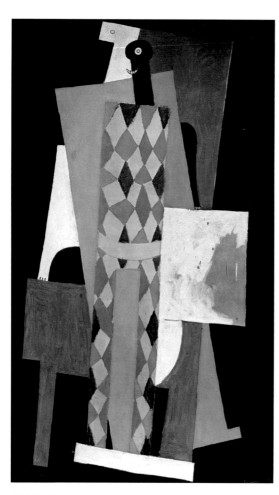

15. Pablo Picasso
Harlequin, 1915
Oil on canvas
183.5 × 105 cm
Museum of Modern Art, New York.
Acquired through the Lillie P. Bliss Bequest

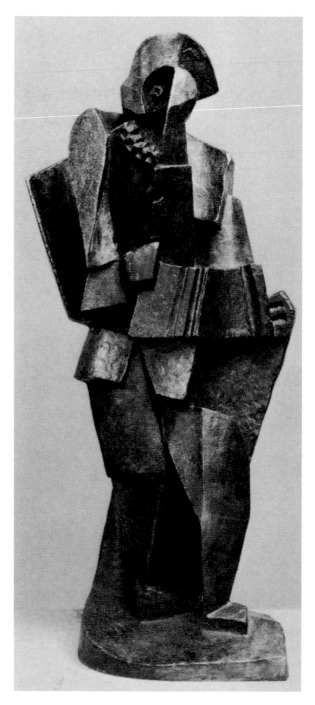

16. Jacques Lipchitz
Harlequin with accordion, 1919
Bronze, edition of 7
76.2 cm high
Marlborough Gallery Inc.

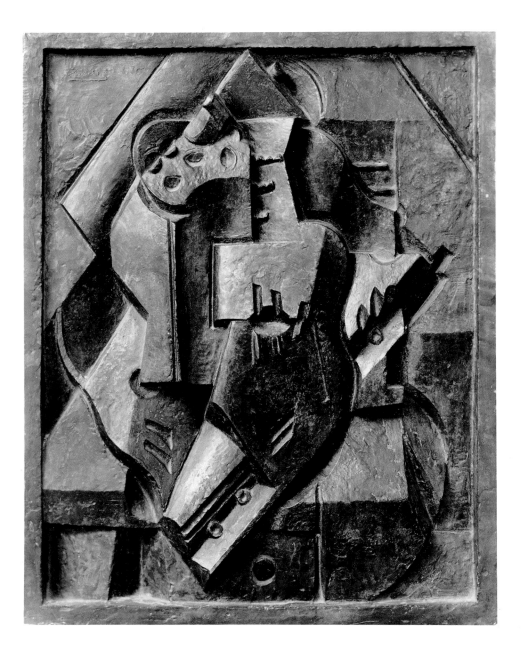

17. Jacques Lipchitz
Still life, 1918
Bronze, edition of 7
68.9 × 55.2 cm
Marlborough Gallery Inc.

early 1920s. Lipchitz was gaining a reputation for articulate and often combative assertiveness and talented self-promotion. He successfully secured the attentions of the leading writers and art critics, seeing the first monograph of his work, by the influential writer Maurice Raynal, published in 1920. He frequented the homes of the leading *beau-monde* figures of the day, including Gertrude Stein, Jean Cocteau and Coco Chanel, each of whom commissioned portrait busts from him, which he executed in a refined, 'classical' manner (figs. 18 and 19). Chanel had a great fondness and respect for Lipchitz, who, with his gift for animated story-telling, would later recount how he had initiated her into the wiles of collector-dealing, winning a bet that he could

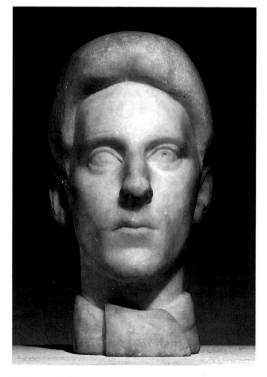

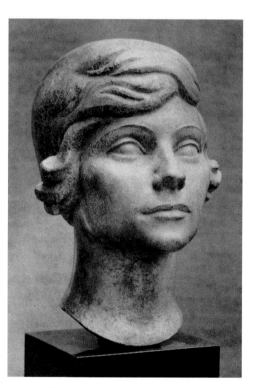

18. Jacques Lipchitz
Portrait of Jean Cocteau, 1920
Marble (unique)
44.5 cm high
Private collection

19. Jacques Lipchitz
Portrait of Coco Chanel, 1921
Bronze
35.6 cm high
Marlborough Gallery Inc.

20. Jacques Lipchitz
Andirons: *Reclining woman*, 1921
Bronze
35.6 cm high
Private collection

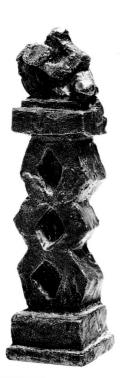

21. Jacques Lipchitz
Study for a garden statue, 1921
Bronze, edition of 7
13.7 cm high
Israel Museum, Jerusalem

make a purchase for her from an antiquarian dealer for a fraction of what she had intended to pay. Her portrait carries an air of the warmth of their friendship, conveying both her fragility and her steely determination. Importantly for Lipchitz, Chanel commissioned some fireplace ornaments for a Louis XV room, which encouraged him in the more fluid, curvilinear style he was beginning to explore (fig. 20). She also asked Lipchitz to produce some ideas for garden sculpture, resulting in the little 1921 maquette (fig. 21), which was not developed further for Chanel, but did generate ideas for Lipchitz's major outdoor work later in the decade.

As for Cocteau, he was enthralled by his portrait, commenting: "The critics have never been able to remove a hair from my head, but Lipchitz has decapitated me The problem was to combine light and shade in my likeness, not by copying my face and then simplifying it, nor by deforming it afterwards on the pretext of style His figures, like certain painted effigies of Picasso, no longer repel as being caricatured humanity. They give us an image of the truer than the true, the real aim of the contemporary artist when he does not limit himself to simple decorative experiments."[3] The energy and presence of the portrait come, as Cocteau realised, from a meticulous technique that uses light to enhance the sense of mass, and builds that mass as from the centre of the work out towards the surface in a tightly

controlled, compacted way. Even while continuing to produce such sculpture for refined indoor, domestic environments, Lipchitz was here working out how the same sculptural principles could be effectively applied to outdoor, monumental sculpture, aware that one of the most difficult challenges facing sculptors after the Great War was to find a form of sculptural monument that spoke directly to modern sensibilities.

One particular work from this period makes Lipchitz's preoccupation with the monumental quite clear, the 1920 *Man with guitar* (fig. 23). An ink-and-graphite study for this piece shows that Lipchitz was envisaging the work elevated on a pedestal, and we see how, typically, Lipchitz combines two different views of his guitarist out of which a third, new figure emerges, incorporating an otherworldly bird-like profile (fig. 22). While only 21 inches (53 cm) in height, this sculpture generates a sense of expansive scale and bulk unlike any of his previous work. Its forms are frontalized and reduced to a tight architecture of integrated blocks. Its emotive force comes not through actual size but from its balance, centredness, mysterious use of shadow and abbreviated imagery. Lipchitz coined a term for these smaller-scale works, "easel sculpture".[4] Only after he met Albert Barnes did Lipchitz have the opportunity to put the ideas they explored truly to the test, in the outdoors, integrated with a pre-existing architectural design.

It was through his reputation as a collector that Lipchitz first met Barnes, introduced, as one collector to another, by the dealer Paul Guillaume, whom Barnes considered at the time his Paris agent. The Merion building was under construction, and Barnes visited Paris with a view to buying paintings and sculptures fitting the Foundation's educational purposes, and as a crucial component of the building itself. A lively correspondence with Lipchitz testifies to the high esteem in which he was held by the American. He toured the Louvre with Barnes, advised him on his purchases from artists and dealers, and they debated passionately about the philosophical and psychological foundations of art. Both men were mavericks of powerful intellect, and were unfortunately to clash badly and somewhat mysteriously in the mid-decade. In the course of their short friendship, Lipchitz received from Barnes probably the most significant commission of his Paris years. The extent and fee for the work were substantial, paying for the new studio designed by Le Corbusier, establishing Lipchitz's reputation as one of the

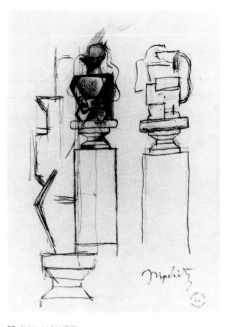

22. Jacques Lipchitz
Study for *Man with guitar*, 1920
Ink and graphite on paper
28.4 × 19.5 cm
Marlborough Gallery Inc.

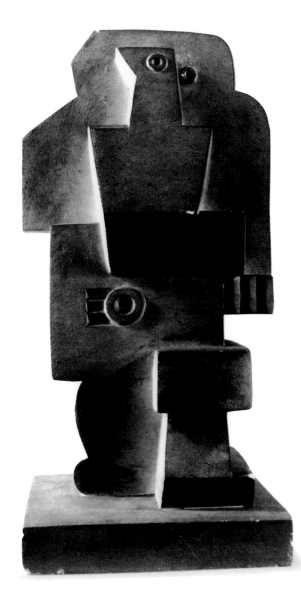

23. Jacques Lipchitz
Man with guitar, 1920
Artificial stone
53.5. cm high
Kunstmuseum, Basle

avant-garde's most prominent and commercially successful artists, and giving him a foothold in the nascent American market for cubist sculpture. The Barnes commission consolidated all that he had learnt about monumental work and gave him the confidence to bring light and air literally into the heart of his constructions.[5]

Barnes's purchases from Lipchitz began with a substantial selection from his previous oeuvre – eight sculptures, including the 1917 *Bather III*. Barnes also commissioned four reliefs, in addition to buying the 1918 *Still life*, for the outside walls of the building, plus a vase to sit in an outer niche, and a new,

24. Jacques Lipchitz
Pastorale, 1923
Stone
The Barnes Foundation,
Merion,
Pennsylvania

free-standing *Bather* to stand on the adjacent lawns. Lipchitz made several versions of this figure, the final one of the series (1923–25; frontispiece), the largest sculpture he had yet made. If we compare one of the commissioned reliefs, *Pastorale* of 1923 (fig. 24 and fig. 34), with the 1918 relief (fig. 17), we can mark a distinct opening-up, or relaxation, of Lipchitz's earlier geometric discipline, as he introduced softer, anthropocentric forms, and figures suggesting a continuous metamorphosis between the human and the inanimate. Lipchitz had not had occasion to visit Merion, but nonetheless it is as if the very setting itself brought a more fluid mix of light and air into the work's conception. Like the 1920 *Man with guitar*, the 1923–25 *Bather* is still very much cubist in concept, with its carefully balanced forms – the arch of the shoulder-blade and upper arm rhyming with the sweep of a long cape – and its staggered patterning of parts, partially revealing, partially concealing meaning. There is now, however, an impression of more vigorous movement around the figure as powerfully articulated sections of light and shade keep our gaze rotating through its forms. It also has a new sense of being firmly rooted through its central axis, this and the sheer bulk of its parts giving it a

formidably totemic quality. It was through contemplating the larger environ-
ment in which this work was to have a practical function that Lipchitz was
led to organize the forms in this way, creating a robust, dynamic style of
outdoor figurative work that would remain his hallmark. By environment,
it is a human environment in the broadest sense that is meant here, which,
by the mid 1920s, he and his contemporaries perceived as being in a state
of constant and unsettling flux. As one highly respected commentator, Elie
Faure, put it in his seminal text, *L'Art moderne* (1921, reprinted 1923), "The
universe is re-making itself. The uncertainty we feel currently in the plastic
arts corresponds with the state of indecision in the sciences, the fundamental
uncertainty of biology as it is now being revealed to us. Our attempts in the
arts at fixing these unstable values within an architectonic patterning
equates to a collective defence against an all-pervasive instability."[6]

The most significant impact this shared outlook had on the sculpture of
Lipchitz, Picasso and others close to them was to invite a reappraisal of how
they used their materials, and to encourage sculptors to ask whether space,
the emptying out of articulation, could not be more expressive than matter
in these shifting contexts. A new sense emerged of the possibility of a highly
charged and deliberately ambiguous sculptural space that grew very much
out of Cubism but expressed doubt in a far darker and more emotive way. Like
Cubism it had still to do with reversals of solid and void, with unexpectedly
shifting perspectives, and with the weight of the untold, of that which
cannot be articulated. Unlike Cubism, it grew directly out of a general aware-
ness of the generative force of the broadest social context, and from the
sense of uprootedness created by those "biological" shifts to which Faure
referred. These most certainly connect with a changing view of the human
psyche and the impact of Freudian psychology in particular on artists working
in Paris, to whom Freud's texts started to become available in French in
1923 – an impact demonstrated most obviously in Surrealism.

Lipchitz always vehemently distanced himself from Surrealism, but
this is not to say that he was not susceptible to ideas related to it. The most
likely channel through which Lipchitz would have been affected by Surrealism
was Picasso, and by means of his imagery. From 1926 onwards Lipchitz's
sculptural imagery became overtly sexualized, frequently exploring the nature
of desire and the drives of the unconscious through the theme of the

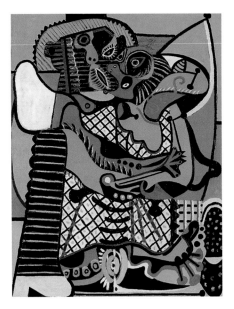

25. Pablo Picasso
The embrace, 1925
Oil on canvas
130.2 × 96.8 cm
Musée Picasso, Paris

embrace, which Picasso supremely unravelled with animalistic, predatory edginess in his canvas of 1925 (fig. 25). The tone of latent aggression and threat underlying Lipchitz's work from 1926 on certainly looks to the highly personalized and erotic colouring of Picasso's painting from the start of 1925. By the late 1920s, the interface of implied sexual and political violence in their work was producing startling new forms that trouble the viewer as they shift through continuous and unpredictable metamorphoses. Lipchitz and Picasso, in the same period, were examining the psychological in two different ways, both of which sprang from highly personal circumstances and yet spoke increasingly to common feelings of malaise. The first has to do with a universalizing, or 'archetypal', symbolism, and is expressed through the linear, through an open space which is cradled, dissected and described by line; the second is much more earthy in its expression, and is characterized by sappy, budding forms that suggest procreation and life-force, a space barely enclosed, bursting at the seams. In both approaches, the artistic explorations followed by the two men ran so closely in parallel that it becomes tricky determining who was the innovator.

Lipchitz's boldest innovation in the 1920s was to propose a new sculpture of line and plane, which used traditional methods of lost-wax bronze casting, but expressed itself through the absence of form, through a space which vibrates with life and takes the sculpture over, as in his 1926 *Acrobat on a ball* (fig. 26). The materiality of the bronze is diminished to the point where it becomes less vivid than the space that it encloses and intersects. Lipchitz called these new open sculptures his "transparents". He devised the process at the end of 1924, and realised it in bronze for the first time in the 1925 *Pierrot* (fig. 28). The transparents were greeted by critics as a revolution in modern sculpture, one which related to older traditions – and the openness and dynamism of Baroque sculpture for example – but which signalled a new emotional register.[7] Interestingly, their appearance coincides with Picasso's dot-and-line drawings (1924), published in *La Révolution Surréaliste* on 15 January 1925. The stellar patterning of these drawings seemed to suggest the outlines of cosmic forces, or the vital skeleton of some living form.

The planar structure and costumed themes of Lipchitz's transparents – many using the characters of the Commedia dell'Arte – can be related to Picasso's two little card constructions of 1919, which Lipchitz probably would

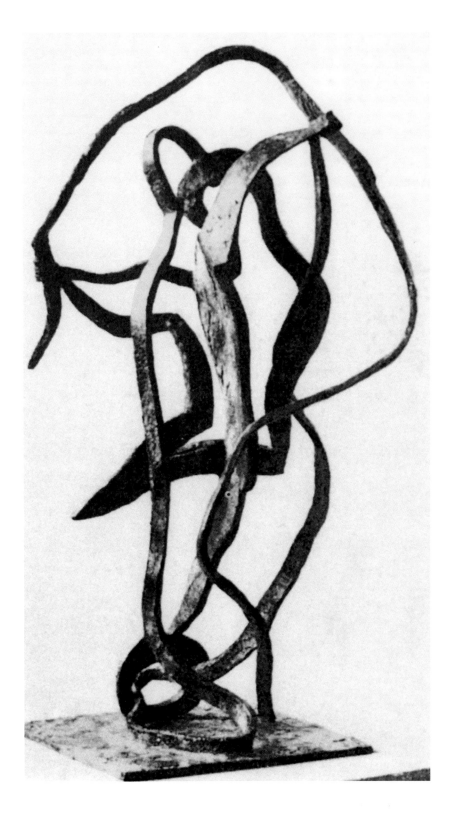

26. Jacques Lipchitz
Acrobat on a ball, 1926
Bronze (unique)
43.8 cm high
Current whereabouts unknown
Previously collection Baroness Gourgaud,
Yerres, France

27. Pablo Picasso
Guitar and table in front of a window, 1919
Paper construction
16.4 × 15 × 10 cm
Private collection

28. Jacques Lipchitz
Pierrot, 1925
Bronze (unique)
19.7 cm high
Marlborough Gallery Inc.

have known (fig. 27). Both Lipchitz's *Pierrot* and the 1919 *Guitar and table in front of a window* capitalize on theatrical conventions of role reversal and masking, catching out our expectations, substituting solid with void to suggest that any core message or meaning will remain illusive. There is also a sense in which these works, and the transparents that Lipchitz went on to make, re-visit early Cubism, in their ambiguity of reference, their double readings, and their use of the two-dimensional to make an unexpected three-dimensional object. The more we see of Lipchitz's transparents, however, especially as he developed them in parallel with open-air, large-scale work, we realise that, unlike Picasso's early constructed sculptures for example, their emotional register now goes beyond precocious technique and visual play. Their quality of space is different, and in this they are closer to the linear patternings of the drawings in *La Révolution Surréaliste* which Picasso would eventually work up into the 1928–29 wire construction *Monument to Apollinaire*. Their space carries with it a tangible feeling for volume, the sense of the actual mass of the human body, which resonates with warmth and psychological complexity. Two particular sculptures demonstrate this well. The first is Study for *Figure: Maquette no. 1* (fig. 29), relating to the seminal 1926–30 *Figure* (fig. 30), and the second is *Reclining figure* (1929; fig. 31), made at a time when Lipchitz had been developing major work based

29. Jacques Lipchitz
Study for *Figure: Maquette no.1*, 1926
Bronze, edition of 7
22.2 cm high
Israel Museum, Jerusalem (also: Stedelijk
Museum, Amsterdam)

30. Jacques Lipchitz
Figure, 1926–30
Bronze, edition of 7
215.9 cm high
Art Gallery of Ontario, Toronto (also: Hirshhorn
Museum and Sculpture Garden, Smithsonian
Institution, Washington, D.C.; Museum of Modern Art,
New York; St Louis Art Museum, Missouri; Norton
Simon Museum, Pasadena, California)

31. Jacques Lipchitz
Reclining figure, 1929
Bronze, edition of 7
22.9 cm long
Marlborough Gallery Inc.

33. Jacques Lipchitz
The joy of life, 1927
Bronze, 355.6 cm high
In situ at Hyères, southern France
(Bronzes also: Forest Park,
St Louis, Missouri; Israel Museum,
Jerusalem; The Meadows Museum,
Southern Methodist University,
Dallas, Texas; Marlborough
Gallery Inc.)

32. Jacques Lipchitz
Reclining woman with guitar,
1928
White stone
Approx. 75.3 cm long
In situ at Le Pradet, southern
France (Bronzes also: Hirshhorn
Museum and Sculpture Garden,
Smithsonian Institution,
Washington, D.C.; Tate, London)

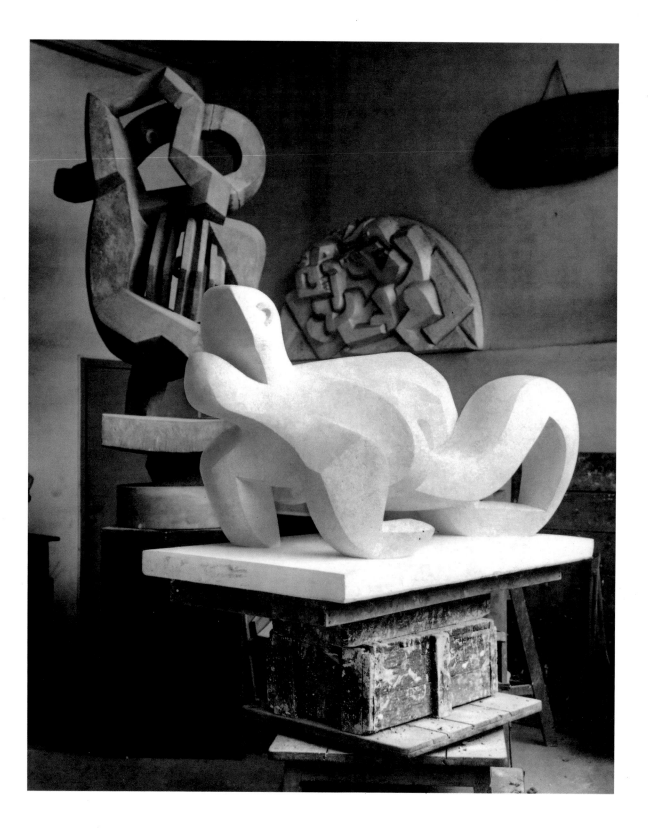

on single reclining figures, notably *Reclining woman with guitar* of 1928 (fig. 32) and on two intertwined figures merging to become a complex new form, as we see in *The joy of life* (1927; fig. 33) and *The couple* (1928–29; fig. 34). The finished *Figure* (see fig. 30) is overtly a fertility symbol. The first maquette for this sculpture suggests, too, that the spaces at its core contain the essential message of the work and that the body is heavy with potential life, as mysterious in its origins and meaning as the abstract calligraphy of the bronze forms. The little 1929 reclining nude (see fig. 31) has a sphinx-like presence: the face is literally emptied of expression and the limbs have been reduced to bone-like forms that seem aged or weathered like flotsam on a beach.

When Lipchitz's younger brother Rubin, a passionate advocate of his work, came to analyse the transparents, he stressed that they arose from his brother's need to "spiritualize sculpture", and that in intention they were a "corollary in sculpture of what Freud was doing for the human brain".[8] On one noteworthy occasion when Lipchitz discussed off the record his discovery of transparent sculpture, he, too, commented that it was not without significance that Freud's ideas were so much in the air at the time.[9] By using an energized space to carry the meaning of his work Lipchitz was, it appears, seeking to explore, or expose, the part of the psyche that is beyond reach, or accessible only though dreams, the irrational, or through illogical juxtaposition. He was attempting to disconnect the normal interpretive mechanisms by a process not unlike automatic writing, letting the line of his 1929 *Reclining figure* maquette drift into improbable directions. The transparents celebrate the fertility of the idea that emerges out of an unformed, meditative state; they refuse to confine meaning, preferring to leave the field of interpretation open; they unlock a new energy akin to the body's normally repressed sexual and psychical energy. For the first time the sculptor felt he could make of his art something infinite, indefinable, without fixed prejudice or morality. Against the background of Surrealism, the openness of this approach was clearly intended as a positive force, militating against any suppression of the individual for the sake of prescribed ideologies or political interests.

By 1930 the erotic drive in Lipchitz's work was becoming more threatening and ambiguous, expressed through themes which became obsessive and were re-worked time and again, taking the memory of a particular gesture or expression and contorting it to the point of the grotesque. One of these

34. Jacques Lipchitz
(foreground) *The couple*, 1928–29
Plaster
Approx. 161 cm long
(Bronzes also: Rijksmuseum Kröller Müller, Otterlo, The Netherlands; Marlborough Gallery Inc.)

(background relief), *Pastorale*, 1923 (see fig. 24)

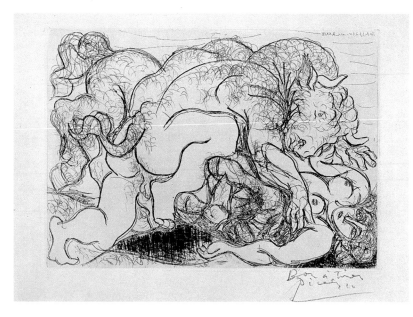

35. Pablo Picasso
Vollard Suite no. 87:
Minotaur assaulting girl, 1933
Combined media
19.5 × 27 cm
Musée Picasso, Paris

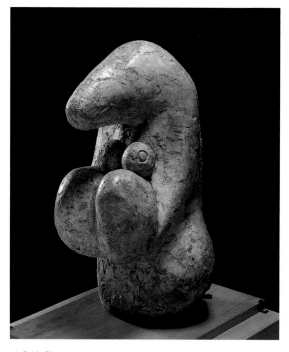

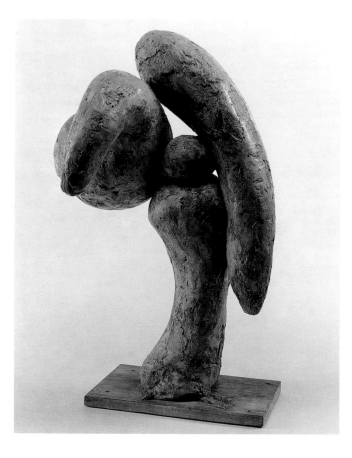

36. Pablo Picasso
Bust of a woman, 1931
Plaster
Approx. 62 × 26 × 36 cm
Musée Picasso, Paris

37. Pablo Picasso
Head of a woman, 1931
Plaster
71.5 × 41 × 33 cm
Musée Picasso, Paris

subjects was a female portrait, based on a pose in which the woman rests her head on one hand. Through the early 1930s Lipchitz produced on this theme countless sculptures in which the forms are brutalized and the features thickened to a point where they resemble the heavy brow of a bull, or the character of the Minotaur that Picasso used similarly to assert his own sexuality (fig. 35). As we note also in Picasso's 1931 sculpted heads of Marie-Thérèse Walter, Lipchitz's female portrait, with its ripe forms, becomes a potent celebration of the dynamic forces of life, renewal, and raw substance, whereby matter itself is supreme in its power of regeneration (figs. 36–38). Another obsessive theme for Lipchitz in the period was that of parental relationships, which are shown to be fraught with anxiety, pain and sexual

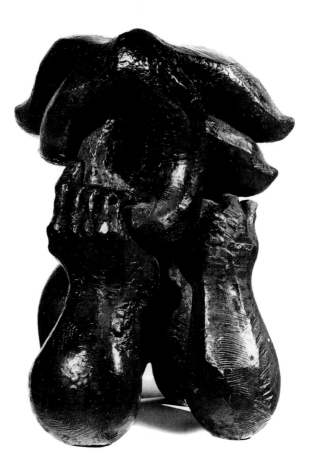

38. Jacques Lipchitz
Woman leaning on elbows,
1933
Bronze, edition of 7
67.3 cm high
Marlborough Gallery Inc.

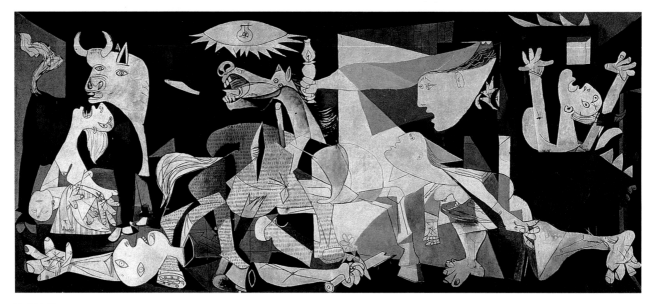

39. Pablo Picasso
Guernica, 1937
Oil on canvas
350 × 780 cm
Museo Nacional Centro de Arte
Reina Sofia, Madrid

rivalry. Lipchitz suggested that his 1931 *Mother and child* maquette, with its arched back, animal-like pose and wrenching scream, made so strong an impact on Picasso that the painter echoed its forms in those of the grief-stricken mother on the very far left-hand side of his 1937 *Guernica* (figs. 39–40), which certainly seems credible.[10] Lipchitz also produced a large *Mother and child* bronze (1930; fig. 41) in which the child occupies the dominant position, aggressively clinging to its mother's breasts.

In 1929–30 Lipchitz turned to biblical subjects and ancient myth, to add greater resonance to this theme of conflict in his work, focusing on the dynamic of two protagonists, and working, as he always preferred, very freely in clay, building up the figures in a rapid, intuitive way. Just as the forms of the little 1929 *Reclining figure* seem to develop as if emerging directly from the unconscious, so one subject now metamorphosed into another, across many sculptures and over several years, as if we were watching the sculptor's ideas evolve against a dream landscape. Using the same basic motif of two wrestling figures which is suggested by the large *Mother and child*, Lipchitz reversed the position of the lower figure to have it face the child, and the confrontation became one of father and son in the 1930 maquette *Return of the Prodigal Son* (fig. 42). The encounter is clearly proposed as one of affection,

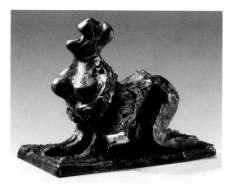

40. Jacques Lipchitz
Sketch for *Mother and child*, 1931
Bronze
13 cm high
Israel Museum, Jerusalem

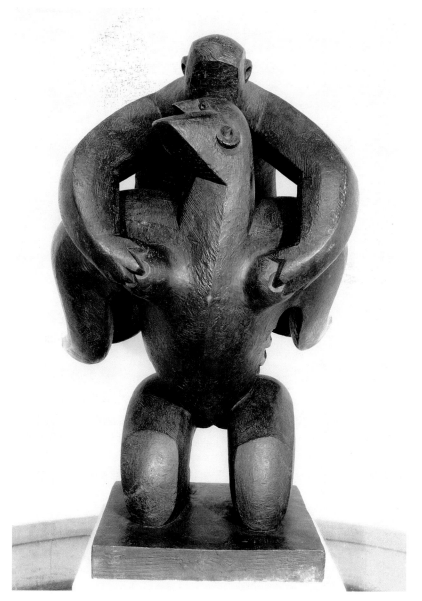

41. Jacques Lipchitz
Mother and child, 1930
Bronze, edition of 7
142.2 cm high
Cleveland Museum of Art (also:
Honolulu Academy of Arts, Hawaii)

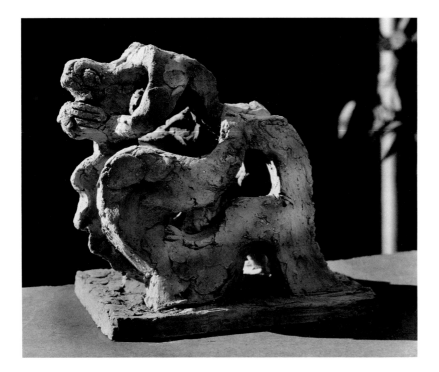

42. Jacques Lipchitz
*Return of the Prodigal Son:
Maquette no. 1*, 1930
Plaster
19.1 cm high
Israel Museum, Jerusalem
(Bronze: Stedelijk Museum
Amsterdam)

by the way the forms melt together, but also one of underlying anxiety, as
the father's spine ripples up into a vulnerable and uncomfortable razor's
edge. This discomfort was softened when the piece was developed as an
outdoor sculpture (fig. 43), but became much more jarring when Lipchitz
transfigured the forms into a fantastic creature that is neither man nor beast,
Man with clarinet (fig. 44). During 1931–32 the element of conflict moved from
latent to overt through a series of works including the 1932 *Jacob and the Angel*
(fig. 45) and the 1932–33 *Bull and swan* (fig. 46).

These battles of will were planned as readable narratives with both a
metaphysical and a political significance. Lipchitz would describe himself
as returning in this period to "story-telling" through the sequence of works
we have followed, "works with an integrated message". He explained, "In the
majority of my sculptures from 1928–45, I was working through a conflict
that was my own but also that of our civilization, its tragedy and catastrophes
in the years when Fascism was on the rise and heading towards its terrible
apex."[11] So, for example, in one of his most explicit sculptures, the 1933 *David
and Goliath* (fig. 47), with its swastika deeply embedded in Goliath's chest,
we are intended to take the political context as our starting-point but also,
because of Lipchitz's mythic treatment of it, to read metaphors of good
versus evil, dark versus light, and the value of struggle and resistance. For

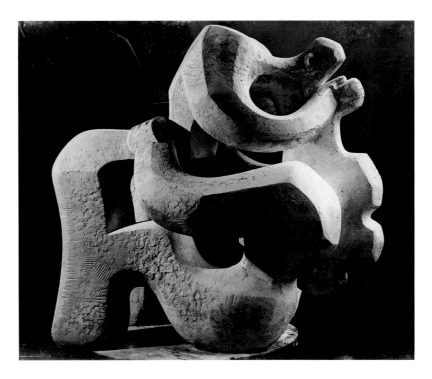

43. Jacques Lipchitz
Return of the Prodigal Son, 1931
Plaster
Approx. 113 cm high
(Bronze: Nelson-Atkins Museum of Art,
Kansas City, Missouri)

44. Jacques Lipchitz
Man with clarinet, 1931
Bronze, edition of 7
17.8 cm high
Marlborough Gallery Inc.

45. Jacques Lipchitz
Jacob and the Angel, 1932
Bronze, edition of 7
124.5 cm long
Openluchtmuseum voor Beeldhouwkunst,
Middelheimpark, Antwerp

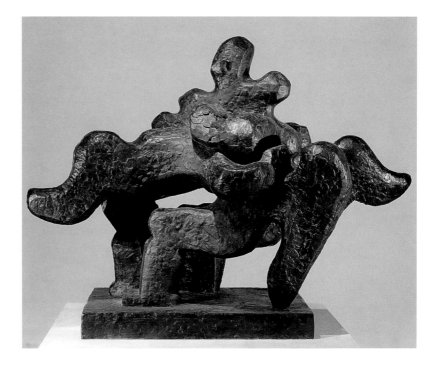

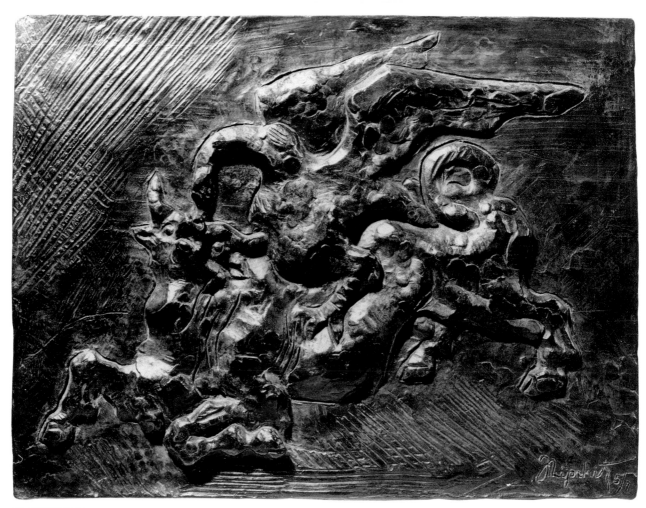

46. Jacques Lipchitz
Bull and swan, 1932–33
Bronze relief, edition of 7
36.5 × 47.5 cm
Israel Museum, Jerusalem

47. Jacques Lipchitz
David and Goliath, 1933
Bronze, edition of 7
99.7 cm high
Marlborough Gallery Inc.

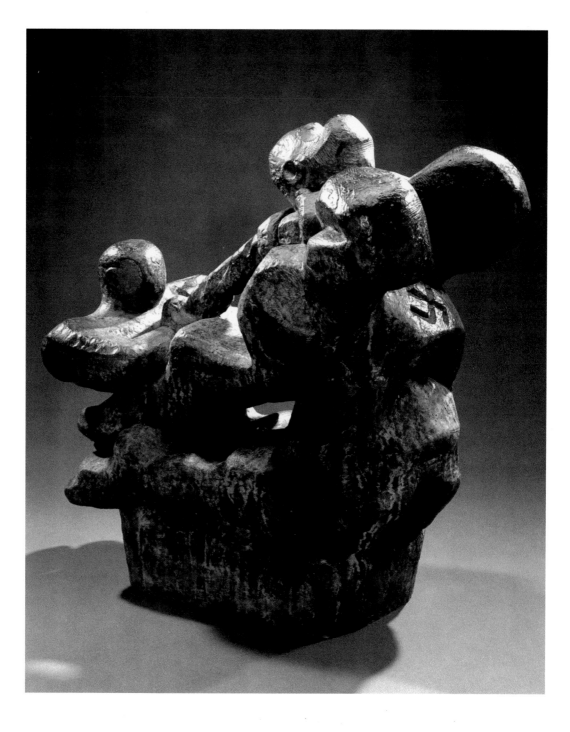

Lipchitz and his circle, the awareness by 1928 of the sheer scale of social change on so many fronts, personal and political, demanded an artistic response that was public. Lipchitz's public standing in France had also matured sufficiently through this period that, where once he had been an artist creating for niche markets and private customers, by the mid 1930s he was being considered as a candidate for major public commissions, even with the strictures on arts spending that followed the 1929 Crash. This was not to say that Lipchitz's status in Paris as a Jewish immigrant who had achieved a degree of security through the Barnes commission was not routinely questioned, and often undermined, by prominent voices within the press and arts establishment. Lipchitz had occasion to feel very personally the effects of the conflicts he described in Europe.

It is no coincidence that one of France's leading writers, André Gide, published his subversive novel *The Counterfeiters* in 1926, with its themes of hypocrisy and self-deception, when images of doubt, dissimulation and questionable identity abounded in the French press. The devaluation of the franc in the mid 1920s and subsequent neurosis about the status of France within the European markets, and the social problems of rising prices and housing shortages, and the unemployment crises of 1924 and 1927, were closely bound to a rising tide of xenophobia and antisemitism.[12] A widespread perception of cynical pragmatism and manipulation in French politics was mirrored within the art world, where metaphors of false currency or value were applied to what was perceived as the sly obfuscation practised by the non-French elements of the avant-garde. Writers in the press such as Marcel Hiver claimed to be able to reveal price-fixing by a few "Israelite dealers", while one of the foremost art critics, Louis Vauxcelles, who was himself Jewish (veiling this fact behind a pseudonym), had railed frequently against the risk of mistaking art by Jewish émigrés such as Lipchitz and Chaim Soutine (1893–1946) for the work of "true" Frenchmen, and the artist and writer Jacques-Émile Blanche had branded these "outsiders" a Tower of Babel encroaching on French soil.[13] Lipchitz in particular had regularly been targeted with comments such as these ever since meeting Barnes, who many like Hiver claimed had been ruthlessly exploited and manipulated by the sculptor, an implausible claim given Barnes's authoritative personality.

Under such circumstances it is understandable that Lipchitz applied for French citizenship, which he received in 1924, and, between 1922 and 1927, with his friend Gris, was a member of the Freemasons, grasping for solidarity, protection and a modicum of integration at a time when Freemasonry was strongly represented within the government and considered progressively republican. Freemasonry undoubtedly also provided an inroad to potential clients. Lipchitz's determination to further his career remained undaunted. He ensured that his work was exhibited at the Salons and reviewed regularly, achieving a coup in 1930 with a major retrospective of his sculpture at the Galerie de la Renaissance – appropriately named indeed, for it was this exhibition which thoroughly surprised critics by the sheer range and energy of the work, startled many with the powerful symbolism of the larger sculptures, including *The joy of life* and *Mother and child*, and re-launched Lipchitz's career as that of an artist fit to tackle monumental work and controversial subjects.

In the early 1930s Lipchitz again transformed his sculpture, as he made a fresh commitment to a far more politicized and socially engaged art. While not directly affiliated to any political party, Lipchitz from the end of 1933 became an active member of the Association des Écrivains et des Artistes Révolutionnaires, which fought to take art out from the galleries and into public spaces. He was also inspired to undertake a trip to Russia in 1935, hoping to find there the secret of an ideal socialist utopia, but was rapidly disillusioned. One of his brothers, Paul, lived in Moscow, and Lipchitz stayed with him, taking time to visit galleries and attend prestigious art events. He soon saw through the surface to the reality of oppression, which was to come back cruelly to haunt him, for only a very short time after his return to France Paul was arrested and executed in the Stalinist purges. Lipchitz's initial idealism about Soviet Russia is reflected in his sculpture of the year before the trip, with its striding, flag-waving motifs (fig. 48), and the sequence of effective studies for a monument (including fig. 49), developing an idea that Lipchitz submitted, unsuccessfully, to a Soviet Arts Commission competition held in Moscow. The driving, twisting motion of the figures in both these projects can be seen to inform the first, 1936 maquette (fig. 50) for the public monument that Lipchitz would finally realise, as he began planning possibly the most controversial sculpture of the inter-war years in Paris – his *Prometheus*.

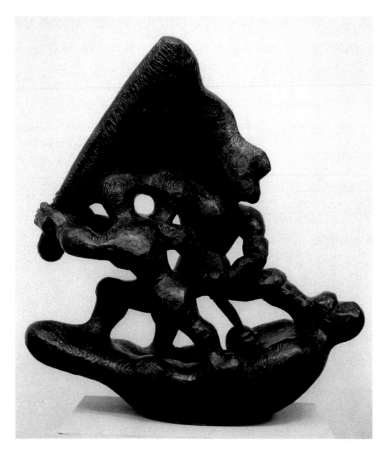

49. Jacques Lipchitz
Study for a monument: *Maquette no. 4*, 1934
Plaster
31.7 cm high
Tate, London

48. Jacques Lipchitz
Towards a new world, 1934
Bronze, edition of 7
115.6 cm high
Marlborough Gallery Inc.

The *Prometheus* commission was one of a number awarded to prominent avant-garde artists for Paris's grand celebration of the 1937 Exposition International des Arts et des Techniques de la Vie Moderne, a grandiose attempt by the Popular Front government at parading a French culture which purportedly integrated elements such as Lipchitz's *clan Montparnassien* (as it had been dubbed by its antagonists,) the cosmopolitan École de Paris, within the embrace of the mother country. Lipchitz was in fact positively honoured, having a room dedicated to his work at the Petit Palais as part of the pavilion that fêted the Maîtres de l'Art Indépendent. Here he presented himself very much as a cubist, showing thirty-six sculptures altogether, including major works from the period 1917–21. Lipchitz was also the only avant-garde sculptor commissioned to create a work for the exhibition on

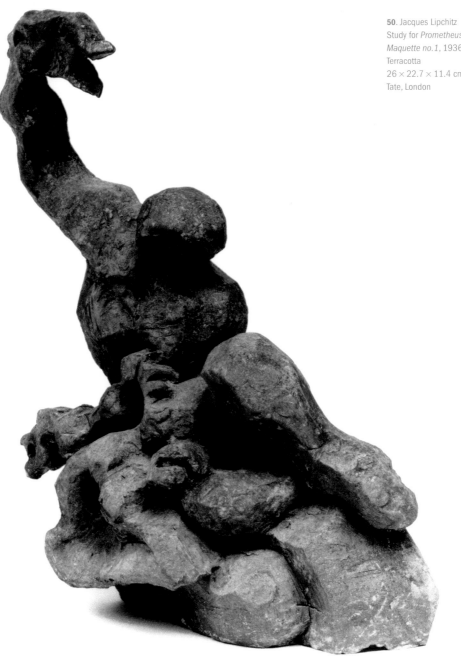

50. Jacques Lipchitz
Study for *Prometheus:
Maquette no.1*, 1936
Terracotta
26 × 22.7 × 11.4 cm
Tate, London

a truly monumental scale. The final piece, *Prometheus strangling the Vulture* stood some thirty feet (9 m) high, and was intended, furthermore, for the top of the grand staircase at the entrance to the Palais de la Découverte, the west wing of the prestigious Grand Palais, as we see it in a rare archive photograph (fig. 51). Lipchitz's official commission came in October 1936, giving him exactly a year before the opening. His contract specified the requirement for a work in plaster which was to celebrate scientific discovery. The eventual Palais de la Découverte displays were indeed an awe-inspiring, fantastic experience, designed to appear like an alchemist's laboratory with great explosions of light and colour in reconstructions that plotted the miraculous pace of modern invention during the preceding half-decade.[14] On receiving the commission, Lipchitz immediately translated his task into the broadest terms, seeking to visualize an image that would mark an unbounded sense of optimism, vital energy and human progress in the face of doubt and prejudice – interestingly making a point of changing the wording on his contract to state that the work should celebrate not "scientific discovery" only, in the literal sense, but "the spirit of discovery".

The idea of developing a sculpture based on the Prometheus myth had been germinating in his mind for many years (he first made a maquette on the subject in 1931). Commenting in later life on the evolution of his ideas on this, the theme that was probably the most important to him across his whole oeuvre, Lipchitz explained that he had from 1933 resolved to adapt the subject as it was traditionally represented in sculpture and painting, so as to make it "less Olympian" and more human, describing a society that was moving into the dark years of its history, and calling for the individual to stand up for democratic values (symbolized by the Phrygian bonnet he added to the Prometheus figure in 1936).[15] Lipchitz liked to stress the symbolism of the struggle with the vulture in the broadest terms of a fight against evil. Nevertheless, in its context, the sculpture makes the most direct political statement, anticipating the eventual defeat of what can be read as the Nazi eagle. The arrangement of the figures went through many stages, beginning with Prometheus only, bearing the Olympic flame; then Lipchitz introduced an already vanquished vulture. Gradually the conflict grew more dynamic and less clearly resolved, as the protagonists became, in the final version, locked in fierce combat, within so compact a composition that their

51. Jacques Lipchitz
Prometheus strangling the Vulture,
1936–37
Plaster
914 cm high
Destroyed
Photograph by Marc Vaux

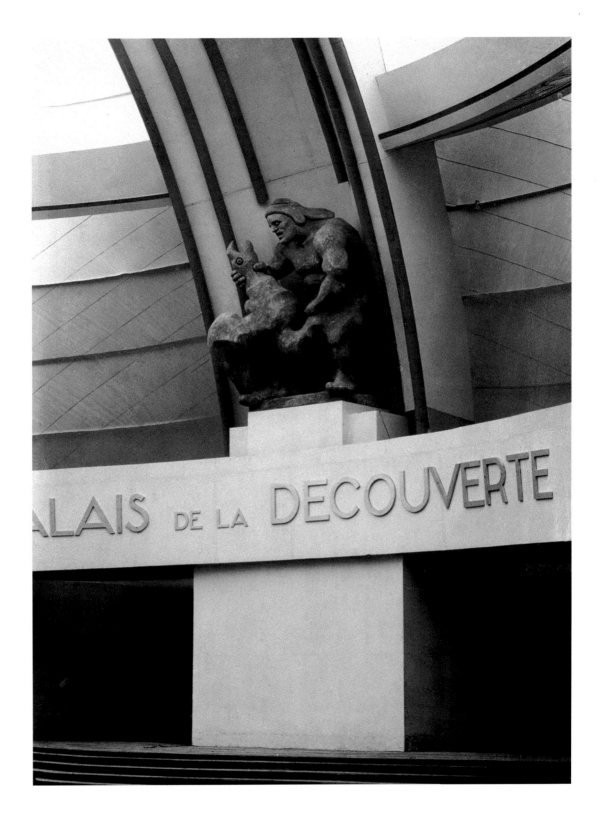

bodies merged. Prometheus's limbs were so thickened that he, too, appeared partially 'bestialized', a fearsome and disturbing representative of titanic struggles through the ages, auguring some terrible, imminent threat.

As Lipchitz developed the final sculpture (fig. 52), his progress was monitored for the exhibition's central organizing committee by his friend Waldemar George. By December it was clear that the sculpture's increasingly fierce and ambiguous imagery was causing the committee some problems. On 25 April 1937 the sculpture was finished and put into place at the head of the staircase. By June suggestions were being made in the committee's reports that the work should be moved to a less prominent position, citing the reason of "technical difficulties" and safety problems. This remained the official line. By 21 July the decision had been taken to move the *Prometheus* to lawns adjacent to the building, and it was so moved without Lipchitz's consent, and to his great fury, that August. As one internal memo from the curator of the Musée de Luxembourg makes clear, the work was deemed to be too antagonistic and thus unfitted for its intended lofty, inspirational setting.[16] If the organizing committee, in the main, politely but insistently rejected Lipchitz's sculpture (which nevertheless managed to win a Gold Medal for its artistic merits), the general public, or rather political factions within it on the conservative right were openly and aggressively opposed. One newspaper branded it "a giant rubbish heap", and voices within the art establishment declared Lipchitz and his ideas a threat to society.[17] In a mood of intense unrest, and under sustained public pressure, the *Prometheus* was eventually taken down from what had been intended as a permanent display in May 1938 and, en route to a storage depot, was ambushed and smashed to pieces, by whom exactly remains unclear. The reaction most certainly compounded anti-semitism with a general public edginess, under the shadow of strikes, the terrorist bombs of September 1937 and rumours of a possible Communist coup.

Ironically, Lipchitz had succeeded in creating a new type of monument that addressed contemporary issues directly, that was immediately readable, and that also opened up the field of moral and social issues in a challenging and ambiguous way, so that the viewer was forced to address the issues it raised – but which, in fulfilling its purpose so well, was destined to be rejected. His effort was both politically ahead of its time and a revival of

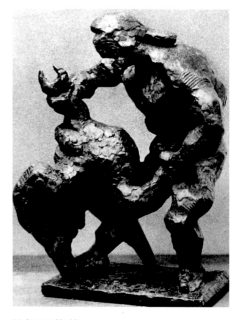

52. Jacques Lipchitz
Study for *Prometheus strangling the Vulture*, 1936–37
Bronze, edition of 7
41.9 cm high
Marlborough Gallery Inc.

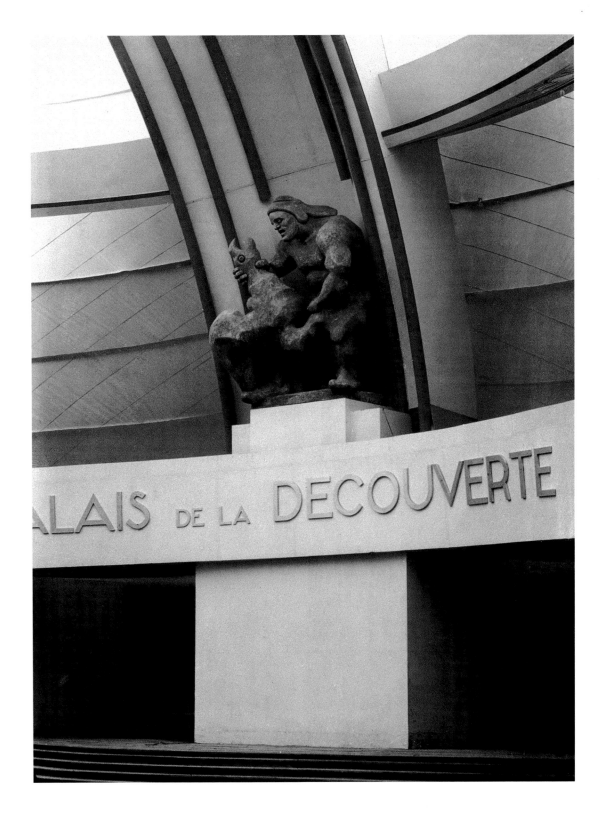

bodies merged. Prometheus's limbs were so thickened that he, too, appeared partially 'bestialized', a fearsome and disturbing representative of titanic struggles through the ages, auguring some terrible, imminent threat.

As Lipchitz developed the final sculpture (fig. 52), his progress was monitored for the exhibition's central organizing committee by his friend Waldemar George. By December it was clear that the sculpture's increasingly fierce and ambiguous imagery was causing the committee some problems. On 25 April 1937 the sculpture was finished and put into place at the head of the staircase. By June suggestions were being made in the committee's reports that the work should be moved to a less prominent position, citing the reason of "technical difficulties" and safety problems. This remained the official line. By 21 July the decision had been taken to move the *Prometheus* to lawns adjacent to the building, and it was so moved without Lipchitz's consent, and to his great fury, that August. As one internal memo from the curator of the Musée de Luxembourg makes clear, the work was deemed to be too antagonistic and thus unfitted for its intended lofty, inspirational setting.[16] If the organizing committee, in the main, politely but insistently rejected Lipchitz's sculpture (which nevertheless managed to win a Gold Medal for its artistic merits), the general public, or rather political factions within it on the conservative right were openly and aggressively opposed. One newspaper branded it "a giant rubbish heap", and voices within the art establishment declared Lipchitz and his ideas a threat to society.[17] In a mood of intense unrest, and under sustained public pressure, the *Prometheus* was eventually taken down from what had been intended as a permanent display in May 1938 and, en route to a storage depot, was ambushed and smashed to pieces, by whom exactly remains unclear. The reaction most certainly compounded anti-semitism with a general public edginess, under the shadow of strikes, the terrorist bombs of September 1937 and rumours of a possible Communist coup.

Ironically, Lipchitz had succeeded in creating a new type of monument that addressed contemporary issues directly, that was immediately readable, and that also opened up the field of moral and social issues in a challenging and ambiguous way, so that the viewer was forced to address the issues it raised – but which, in fulfilling its purpose so well, was destined to be rejected. His effort was both politically ahead of its time and a revival of

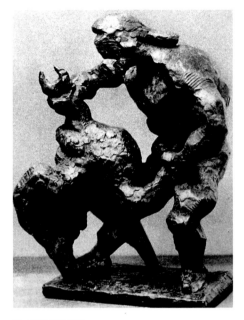

52. Jacques Lipchitz
Study for *Prometheus strangling
the Vulture*, 1936–37
Bronze, edition of 7
41.9 cm high
Marlborough Gallery Inc.

great works of public sculpture such as Rodin's *Balzac*. This had likewise been pilloried by contemporaries, but had just before, coincidentally, been cast in bronze for the Musée Rodin in 1936, with a further cast made in 1937 finally resolving the conflict of the 1880s with its public installation on the Boulevard Raspail. Lipchitz would eventually resurrect his idea for a *Prometheus* monument in America. In France he had come perhaps too close to a common raw nerve. At the same time, he signalled the way towards a new post-war monument, by focusing on emotional authenticity, personal experience, psychological complexity, and an alert sense of environment. For, if Lipchitz's sculpture had been allowed to remain in the position for which it had been designed, the public would have seen that it set up a suggestive form of conversation with its surrounding architecture within the Grand Palais (which had been especially draped and simplified for the international exhibition). The sculpture's baroque forms, by their very exaggeration, heightened the drama of the human narrative, but also threw into sharp relief the linear quality of their architectural backdrop. Lipchitz had understood that the simpler, the more classic, or even abstract, the architectural setting, the more elaborately expressive the accompanying sculpture needed to be, so as to inject all the energy and vicissitudes of the human imagination into otherwise cold and functional urban environments. In America Lipchitz's emerging gift for architectural sculpture would be better recognized.

1. Lipchitz discussed the influence of his father frequently when interviewed in later life. One of the most useful statements he made on this subject, including mention of Le Corbusier, forms the introduction to *Art in Architecture*, ed. Louis G. Redstone, London and New York 1968.

2. A very useful personal account of Lipchitz's career is provided by Waldemar George's own typed notes, *'Notice biographique'*, reproduced in the Chronology below (Tate Library exhibition catalogues file.)

3. Jean Cocteau, 'Jacques Lipchitz and my portrait bust', *Broom*, vol. 2, no. 3, Rome, June 1922, pp. 207–09.

4. Lipchitz in conversation with Deborah Stott, Pietrasanta, Italy, 14 July 1969; transcript Tate Archive.

5. For a detailed account of the Barnes-Lipchitz relationship see C. Pütz, 'Towards the Monumental – the Dynamics of the Barnes Commission', in *Lipchitz and the Avant-Garde*, exhib. cat., Krannert Art Museum, University of Illinois at Urbana-Champaign, 2001–02.

6. Elie Faure, *L'Art moderne*, 2nd edn, Paris 1923, pp. 49off.

7. The first review to discuss the transparents was by Waldemar George, 'Bronzes de Lipchitz', *Amour de l'Art* (Paris), 1926, pp. 299ff.

8. Rubin Lipchitz, September 1964, private notebook, Tate Archive File A17.

9. The unpublished interview, by an unnamed interviewer, was held in Pietrasanta in the late 1960s or early 1970s. The transcript is held in the Lipchitz archive of the Musée d'Art et d'Histoire du Judaïsme, Paris; the passage used appears at p. 11.

10. Private letter by Lipchitz, 'Notes à servir de guide', Tate Lipchitz Archive, File A9.

11. Lipchitz, unpublished interview given at Pietrasanta, Italy; transcript held in the Lipchitz archive at the Musée d'Art et d'Histoire du Judaïsme, Paris, file A190.1 and 2.

12. Important analyses of the social tensions in France between the wars and their origins are to be found in Ralph Schor, L'Opinion Française et les étrangers, 1919–1939, Paris 1985, and Eugen Weber, The Hollow Years, New York and London 1994.

13. Marcel Hiver, Cahiers du CAP (Paris), issue 7, 1 April 1927, pp. 12–13; Louis Vauxcelles (Louis Meyer), 'La Querelle des étrangers', Ère Nouvelle (Paris), 29 November 1923; Jacques-Émile Blanche, Les Arts Plastiques, Paris 1931, p. 322.

14. Full details about the Palais de La Découverte displays, with records of Lipchitz's commission and press cuttings describing the tremendous impact of the opening, are to be found in the Archives Nationales, Paris, especially files F/12/12181 and /12147.

15. Jacques Lipchitz, 'The Story of my Prometheus', Art in Australia, series 4, June–August 1942, pp. 29–35.

16. M. Hautecoeur to M. Morane, 1 April 1938: "It was decided that the character of this work seemed inappropriate to the original setting"; Archives Nationales, as note 14.

17. Le Matin, 29 April 1938; the reaction of the Association des Anciens Élèves de l'École des Beaux-Arts is reported by Lipchitz in the Art in Australia article, as note 15.

III The Promethean Paradox

After Lipchitz's move to America in 1941, he found more than ever that the drama of classical myth formed the most effective common ground between the political situation and his own artistic imagination. World events occupied his mind with such persistent foreboding that only images of Titans and the most fantastic creatures could come close to describing his experience. His family was scattered worldwide – his first wife and his closest brother, Rubin, remained in France, his sister and his nephew, Georgy, whom he regarded like a son, were in Eastern Europe – and he had constantly to fear for their safety and well-being. Throughout his American career, while he maintained a frenetic artistic output, his health regularly collapsed as his nervous energy was stretched to the limits. This intense nervous strain and a sharpened moral imperative are the driving forces behind Lipchitz's later work. Of the various mythical figures on whom he chose to project his anxieties, whether Theseus fighting the Minotaur, Jupiter bearing off Europa, or Bellerophon taming Pegasus, it was Prometheus who remained the most significant protagonist in the sculptor's theatre of human struggle.

The character of Prometheus continued to determine the forms that his heroes would take, literally and symbolically. Lipchitz spent most of 1944 working again on the Prometheus theme. His first commission, secured with the help of the Museum of Modern Art in New York, was to make a sculpture for a new Ministry of Education and Health Building in Rio de Janeiro. For this Lipchitz produced a particularly vigorous version of *Prometheus and the Vulture*, using an animated, open composition, full of light and texture, showing the two figures propelled through the air in the heat of combat. It well suited the severe and uniform architectural backdrop. Through a gross misunderstanding the final work that was mounted into

position was only one-third the size that Lipchitz had indicated and he consequently disowned the whole project. Nevertheless, the dynamism of the work can be appreciated from two further bronzes that were made, one for the Philadelphia Museum of Art and the other for the Walker Art Center, Minneapolis (fig. 53).

It was immensely important to Lipchitz to begin his new career with this motif. Prometheus, driven by ambitions that were colossal in their vision and compass, represented for him optimism on such a scale as to defy the most malign reality. For Lipchitz, he was the supreme rebel, the outcast who elected to defy the basic ground-rules he was set by giving fire to humankind.

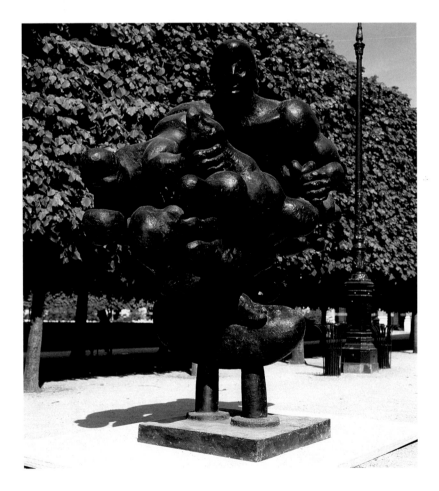

53. Jacques Lipchitz
Prometheus strangling the Vulture, 1944–53
Bronze, edition of 2
236.2 cm high
(Philadelphia Museum of Art and Walker Art Center, Minneapolis, Minnesota)

Thus he not only provided the means to produce tools and weapons, but was equally to be considered the father of sculpture and of the process of bronze-casting, which remained Lipchitz's favoured medium. With harsh irony, the gift that Prometheus offered came to test Lipchitz in the extreme, when his New York studio and years of work were demolished in a fire in 1952, forcing the artist to re-build his life fundamentally. Appropriately, Promethean fire is, in the Greek creation myth, also the symbol of survival, conferring immortality on the figures (such as Achilles) that it envelops. Prometheus became, in Lipchitz's mind, an everlasting representative of 'the artist', tormented and tested in his desire to master the natural universe and its laws, yet through those very trials pointing out a mysterious way of distilling the most lasting values from the morass of experience.

When Lipchitz reviewed the product of his years in America and, latterly, in Pietrasanta, Italy, he considered it to be a successful and unified expression of this anatomy of conflict, struggle and transformation, both in personal and in the broadest social terms. Its articulation, tested through the fire of experience, underwent constant, often surprising metamorphoses, as he created work that appeared to be far removed from the sculpture he had produced in France. Lipchitz fully realised that his later sculpture might be seen as inconsistent, yet he was confident that the work's liberal, humanitarian themes and values remained nonetheless clear, indeed were made all the more universal by this rich diversity.

This has not in fact been the common view, and Lipchitz's later work is generally undervalued, condemned for the very characteristics which, to Lipchitz, defined its strengths – its endless variety, its extravagant yet vital imagery, the value it conferred on the individual's imagination. According to detractors of Lipchitz's American work, most prominent amongst them Clement Greenberg, the Promethean scale of the sculptor's ambitions drove him to an excess of emotional expressionism that tipped the sculpture into caricature. Greenberg saw in the later work a most frustrating paradox, an oeuvre which defined the potency of modelled sculptural form at its most accomplished, but was consumed and ultimately weakened by that very dynamism. Greenberg described the extreme discomfort that the later work gave him – its "bloated volumes, coarse contours and arbitrary elaborations" – explaining further: "Great and instinctive modeler though he was and is,

Lipchitz began to model excessively, self-indulgently, over-eloquently Since detaching himself from Cubism he has been unable to develop a principle of inner consistency He has the superlative and inalienable power to knead matter into massive, simple, and energetic form – unlike Picasso he has never lost his 'touch'. What he does seem to have lost is a sure reliance on anything inside himself."[1] Through fulfilling his potential, Prometheus had paradoxically gone too far, as he had in Hesiod's interpretation of the Greek myth, bringing Zeus's wrath and humiliating defeat and anguish onto humankind. The sculptor, according to this version of the tale, had exceeded the capacities of his artistry at the point where he realised them most triumphantly.

For Greenberg, the problem, which he never quite managed to fathom, lay somewhere around the area of Lipchitz's relationship, or lack of relation, to Cubism, his detaching himself from that movement and its principles. Strangely it is that very relationship with Cubism, once we understand how Lipchitz perceived it, which offers a counter-argument to Greenberg's, and a defense of Lipchitz's later work. As Lipchitz stated many times, he considered himself a cubist throughout the entire length of his career, and he insisted that cubist principles informed the post-1941 sculpture. Thematically he broadly continued to work with the same ideas in America as he explored in France. The later sculpture falls loosely into three groups: investigations on the theme of maternity (in America we find again the Mother and child subject, also a marked emphasis on religion, and the new subjects of Hagar and of the Virgin); secondly, the development of his small transparents in even more fanciful and technically ambitious ways; thirdly, his architectural work, including his two most successful public monuments, *Bellerophon taming Pegasus* (1964–73; fig. 54) and *The Government of the People* (1967–70; fig. 55). The qualities informing monumental sculptures such as these, which Lipchitz associated with the lessons of Cubism, are the rigorous balancing and rhyming of their parts; their taut internal architecture, with its sense of building mass compactly outwards from an anchored core; and the autonomy of the work, achieved through the energetic distortion of natural form and the intervention of light as it effects the way we read the sculpture and creates the impression of actual movement. The ambiguity and multiple readings of the subjects recall Lipchitz's 'high' cubist works, where different

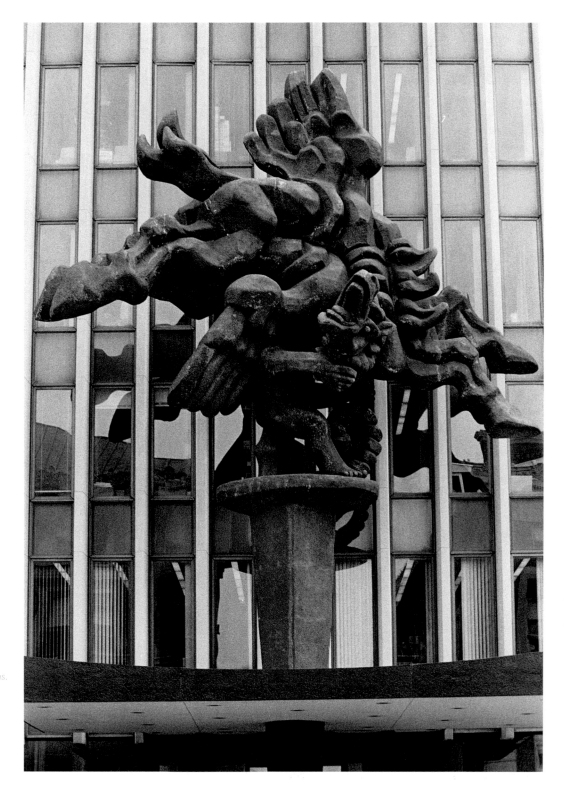

54. Jacques Lipchitz
Bellerophon taming Pegasus.
1964 73
Bronze (unique)
Approx. 11.4 m high
Columbia University in
the City of New York,
Gift of the Alumni to
the Law School, 1977

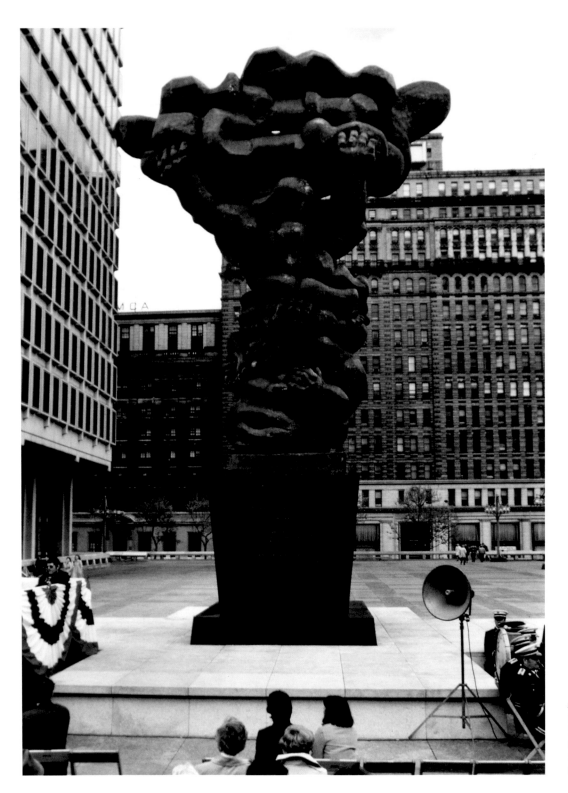

55. Jacques Lipchitz
The Government of the People,
1967–70
Bronze (unique)
10.5 m high
Municipal Plaza, Philadelphia

views of one sculpture suggested at one time a head, at another a three-quarter-length figure. In the later monuments, the overall reading of a single figure is often subdivided into layers of figures on a smaller scale.

To achieve a sculpture which works well out of doors and when viewed from a distance demands great formal discipline, and Lipchitz saw Cubism on the one hand as a rule-book with clear, methodical steps towards achieving structures that have all the authority of natural forms. If in France Lipchitz had been assimilating those rules, in America he took them more literally head on, vying with Cubism, utilizing its principles while challenging them. When discussing the *Between Heaven and Earth* and *Peace on Earth* sculptures (figs. 56, 57), which relate to *The Government of the People*, Lipchitz commented: "As I conceived it, the figures below constituted humanity receiving the Virgin . The idea has something to do with the songs and rituals of primitive people and also, curiously, in my mind about some of the regulations and taboos involved in the beginning of Cubism. This latter fact pushed me further in the direction of freedom and lyrical expression, away from the dictatorship even of ideas, towards images of the unity of humanity."[2]

There was also in Lipchitz's mind a dimension to Cubism quite different from the rule-book variety, which was the reason why, as we have seen previously, he always called it the most human art form. This was the dimension that proposed precisely the act of freeing the imagination and the breaking of mental taboos described in this passage – a very human empowering of the individual over and above the structures that seek to bind him. Here we arrive at an aspect of Cubism that is frequently underestimated, namely its capacity for incorporating the mystical and illogical. Quite unexpectedly, the strongest conceptual link between Lipchitz's early and late work revolves around the question of alchemy and magic. It is the presence of this unpredictable dimension, in a more overt form than Lipchitz would have allowed himself in Paris, which also explains the eccentricity of the later sculpture that so irritated many of its critics. Antagonists such as Greenberg, misled by its surface diversity and loquacity, missed its latent message about Cubism: the fact that cubists such as Lipchitz had even before the 1920s been working far closer to the territory that the Surrealists would occupy than they would have confessed. For their art, too, was about the primacy of the individual's most private visions, and the power of the unconscious to manipulate

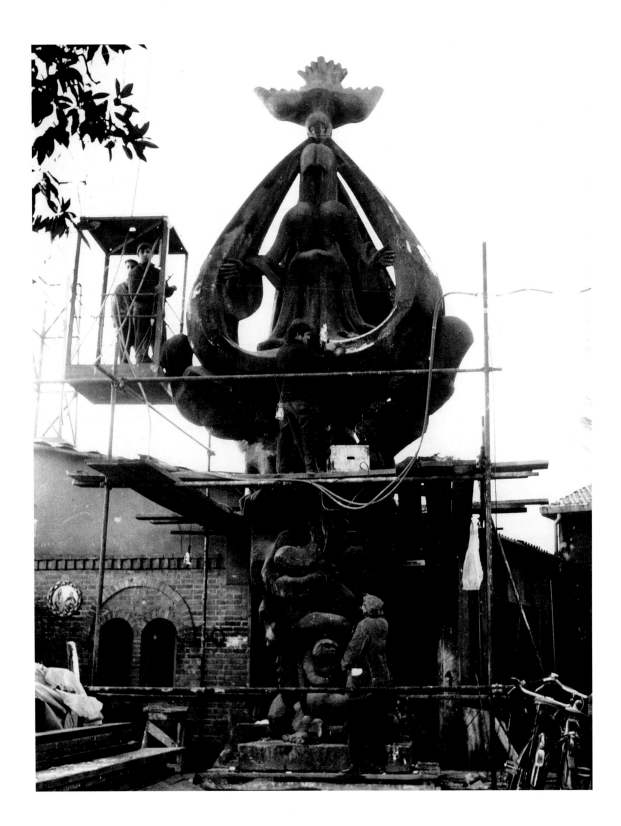

64

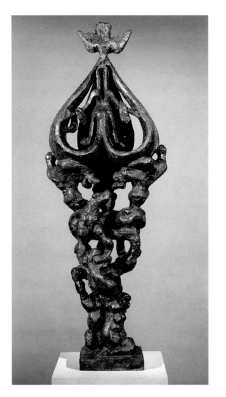

57. Jacques Lipchitz
Between Heaven and Earth II, 1958
Bronze, edition of 3
114.3 cm high
Marlborough Gallery Inc.

56. Jacques Lipchitz
Peace on Earth, 1967–69
Plaster
Approx. 8.8 m high
(Work in progress at the Tommasi
Foundry, Pietrasanta, Italy)

experience and produce new, unseen forms with an anarchic élan that challenged all élitisms.

In Lipchitz's utopian vision of Cubism, the sculptor was no longer to be seen as a labourer (an image once evoked by Leonardo, and which troubled Lipchitz throughout his life): he was far more a magician, who brought out the supernatural qualities in the everyday.[3] This was the imagery that Lipchitz prompted his friend Waldemar George to use when presenting the small-scale work that grew out of his transparents to its new audience in America. In 1942 Lipchitz began thinking again about the transparents, but wanted to produce work that was more spontaneous and more lyrical, pushing his medium to the extreme. After the tragedy of the studio fire, he finally achieved the release of experimental energy that he sought, and produced two types of smaller, modelled sculpture, one series made by simply dropping hot wax into water and allowing it to take shape rapidly between his fingers – what he called his "semi-automatics" (figs. 58–60). In the next series, he managed to incorporate actual leaves, twigs and flowers into tiny models which were then cast in bronze, producing works that he named *To the Limit of the Possible* (figs. 61–63). These fantastic and delicately evocative pieces were exhibited in the winter of 1959 at the Fine Arts Associates (FAA) gallery in New York, and George wrote a short text to appear on a loose insert in the catalogue. As has been newly revealed by the Hastings-on-Hudson studio archive of Lipchitz's American years, in a draft version George entitled this essay 'Sculpture and Evasion', which was changed by the sculptor to the final 'Sculpture and Sorcery'. Lipchitz also crossed out a passage that read: "Lipchitz as craftsman constructs these figures . . ." and changed it to "Lipchitz acts as a diviner".[4] The sculptures featured in the FAA exhibition do indeed appear like images from another world, or else some fleeting glimpse of a Shakespearean Puck or Caliban. George commented, "Lipchitz . . . communicates with the forces of the world and returns to art the sense of the marvelous. A new Icarus, he violates the laws of weight and balance." George cited Lipchitz's own words to open the essay: "The sculptors will probably say: this is no longer sculpture; the art-historians will declare: perhaps this is no longer art." The reality was that contemporary artists reacted very favourably to what they saw. The sculptor David Smith, for example, was following Lipchitz's progress with great interest.

59. Jacques Lipchitz
Head of Harlequin, 1955–56
Bronze (unique)
30.5 cm high
Marlborough Gallery Inc.

58. Jacques Lipchitz
Mater dolorosa, 1955–56
Bronze (unique)
31.1 cm high
Marlborough Gallery Inc.

60. Jacques Lipchitz
Only inspiration, 1955–56
Bronze (unique)
22.9 cm long
Marlborough Gallery Inc.

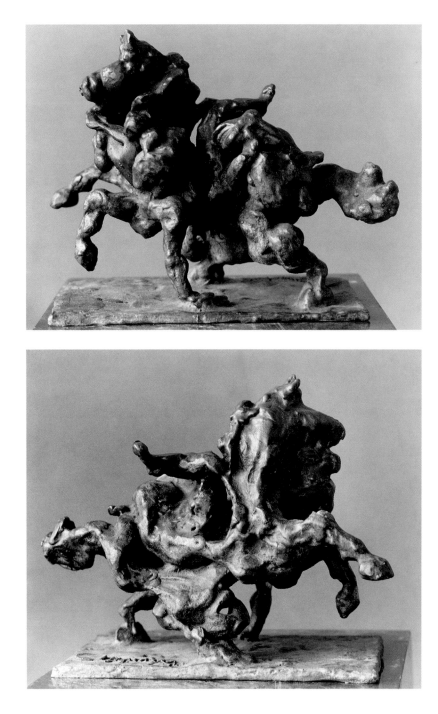

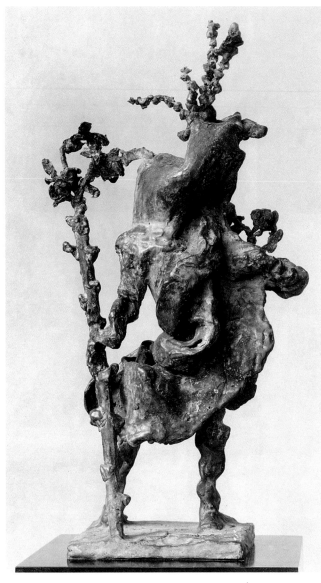

61. Jacques Lipchitz
Carnival, 1958
Bronze (unique)
45.1 cm high
Marlborough Gallery Inc.

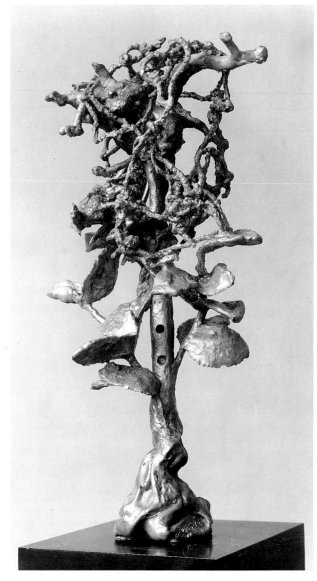

62. Jacques Lipchitz
Marvellous capture, 1958
Bronze (unique)
45.7 cm high
Marlborough Gallery Inc.

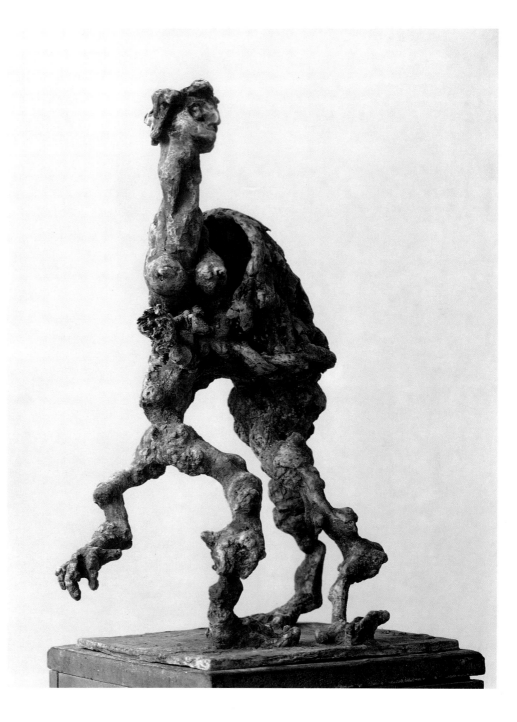

63. Jacques Lipchitz
Galapagos II, 1958
Bronze (unique)
49.5 cm high
Marlborough Gallery Inc.

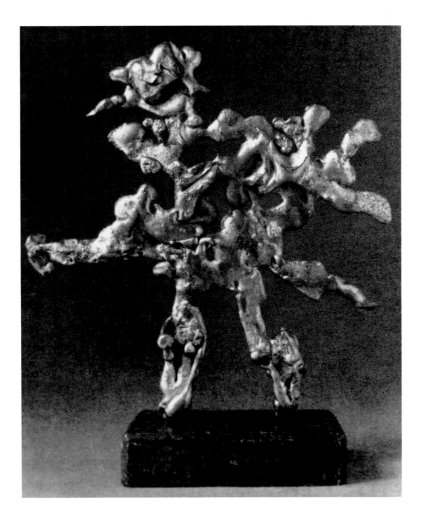

64. David Smith
Europa and the calf, 1956–57
Poured bronze on stone base
28.8 × 24 × 9.5 cm
Smithsonian American Art Museum,
Washington, D.C.

As Jonathan Fineberg has pointed out, Smith's *Europa and the calf* (1956–57; fig. 64) had surely been made with Lipchitz's favourite motifs as well as his semi-automatics in mind.[5]

Lipchitz was well ahead of his time in devising a loosely modelled sculpture that explored images of mystical transformation in a private and inscrutable way, one which drew liberally from across a broad spectrum of arts and sciences. George in the same essay noted that "the small bronzes . . . inaugurate the era of metamorphoses and polymorphism The symbols of telluric forces borrow their images from anthropology, zoology and botany." Indeed, the field of sciences can be extended further still. Fixing in our minds that image of Lipchitz, as he himself proposed, as diviner, we can establish that the sculptor was consciously returning to the role of the artist as he and Gris had perceived it at the height of their cubist collaborations in

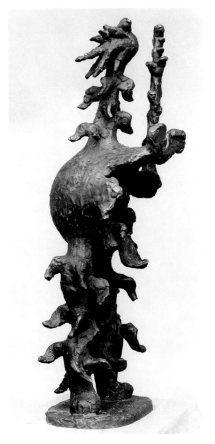

Paris (1916–20). At the time, the two friends were deeply immersed in the science of the occult, seeking to establish principles for their artistic practice that related to the most mysterious laws of the universe. In that same 1947 letter to Kahnweiler with which this consideration of cubist sculpture opened, Lipchitz emphasized: "You should know that, at the time I knew Gris, I was deeply engrossed in the occult sciences. It was I who lent him the treatise on the occult by Eliphas Levi and who introduced him to the writings of the unknown philosopher St Martin. The Emerald Table [by the medieval mystic Paracelsus] was my bedside reading. And it was no hocus-pocus that we were after, but rather the practical aim of discovering how to transfigure the prose of reality into the pure gold of poetry."

Significantly, in America, as is clear from the Hastings archive, Lipchitz through the 1950s and 1960s regularly sent for books from Paris on the history of magic (via his first wife, Berthe), and he specifically requested in 1961 a copy of *The Emerald Table*. By presenting himself to his American public as Diviner, he was making a purposeful connection back to the role he had adopted in Paris, defined in an important early essay on his work by his friend Roger Vitrac as that of "fakir, sorcerer, seer, priest".[6] In Lipchitz's own opinion, the work of his American years more completely fulfilled that earlier mission of transposing a crude metal into refined poetry than anything he had done before, and in this sense it brought him back to the essence of his Paris Cubism, which he had very deliberately set out to re-visit.

The active element of 'magic', or poetic mysticism, in the later work takes two forms. One is manifest in the smaller bronzes, from the 1942 *Pilgrim* (fig. 65) and 1946 *Aurelia* (fig. 66) through the whimsical series *Variations on a Chisel* and the *Begging poet* of 1951–52 (fig. 67) to the 1970–71 *Pierrot* (fig. 68). Of this type, the fourteen works in the *To the Limit of the Possible* series are certainly the most effective, and *Enchanted flute*, for example (1959; fig. 69), demonstrates a skilful transformation of its material, as bronze is made to seem as delicate as lace. Lipchitz is drawing out the 'hidden' properties of a metal that retains every slight trace of the human touch, and can convey the spontaneity of the modeller's ideas at the very moment they appear. As Lipchitz wrote, "I have tried other metals, such as aluminium, but bronze is my first and continuing love because it is so alive, so direct, so warm and fluid. Each piece has my fingerprints all over it." In the same text he expanded

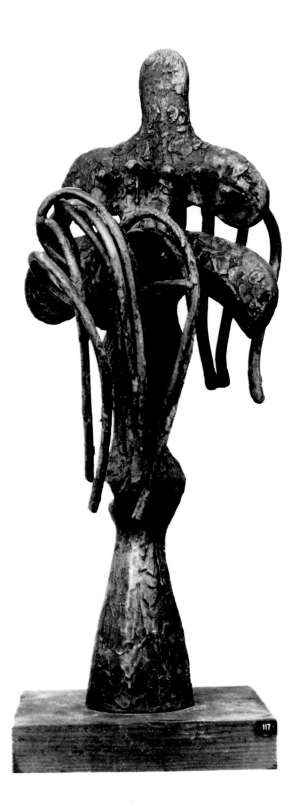

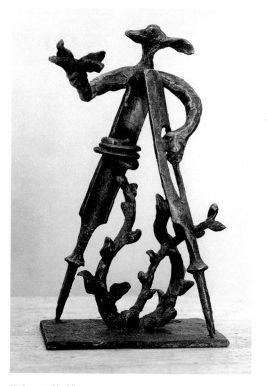

66. Jacques Lipchitz
Aurelia, 1946
Bronze (unique)
64.5 cm high
Peggy Guggenheim Collection, Venice
(also: The Solomon R. Guggenheim
Foundation, New York)

67. Jacques Lipchitz
Variation on a chisel VI: Begging poet, 1951–52
Bronze (unique)
21.6 cm high
Marlborough Gallery Inc.

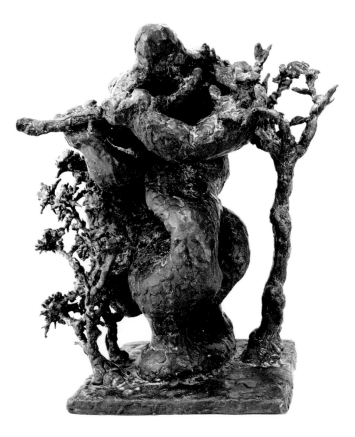

68. Jacques Lipchitz
Pierrot, 1970–71
Bronze (edition of 7)
37.5 cm high
Marlborough Gallery Inc.

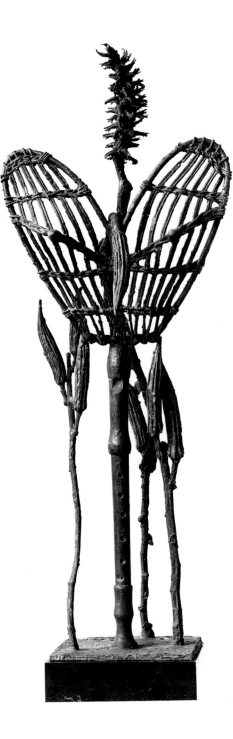

69. Jacques Lipchitz
Enchanted flute, 1959
Bronze (unique)
52.1 cm high
Marlborough Gallery Inc.

on his purpose, explaining how for years working with clay models he had tried to achieve an almost impossible combination of the conscious and the unconscious, through motifs which moved "from the unconscious or automatic gesture to the conscious sculptural structure and back to a final unconscious realisation". In their final form these models were intended to appeal to the deepest levels of his viewer's consciousness, their most creative processes of sign recognition.[7] In America in the 1950s he appears to have succeeded. In this sculpture, for example, we feel free to interpret its forms in any number of ways – its fine meshing evokes butterfly wings, or an open flower, the qualities of its bud- and stamen-like forms so tactile that they become subtly erotic.

The second type of 'magic' takes this manipulation of bronze in another direction, moving from the personal to the general, but the processes of creation are similar. It has to do with the feeling for volume that develops in his later monumental work and the way in which forcefully modelled form can embody deep-rooted fear and longing, a vision of sculpture which had begun to develop for Lipchitz in the 1930s. It is the subconscious that is stressed when Lipchitz talks about a sculpture such as *Mother and child* II (1941–45; fig. 71), an image that he claimed emerged unexpectedly and intact, a long time after an actual event, from the memory of a terribly deformed woman he had seen in Russia, re-appearing in his mind at a time when he was made ill with horror at the events of the Second World War. He produced in this work a memorial to the terror of war and genocide as trenchant as Jacob Epstein's icon of the Great War, *The rock drill* (1913–16; fig. 70), a figure also deformed and psychologically disfigured, presented with the same brutal honesty. It was this potency of image-making that Lipchitz meant by his particular use of the word "*mystère*", that element of "mystery" he often described in Rodin's work. What enthralled him was its uncanny ability to make strange the forms of the human body, to convey the metaphysical, and to offer an intuitive awareness of human vulnerabilities.

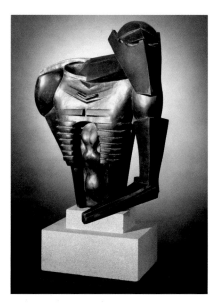

70. Jacob Epstein
Torso from *The rock drill*, 1913–16
Bronze
70.5 × 58.4 × 44.5 cm
Tate, London

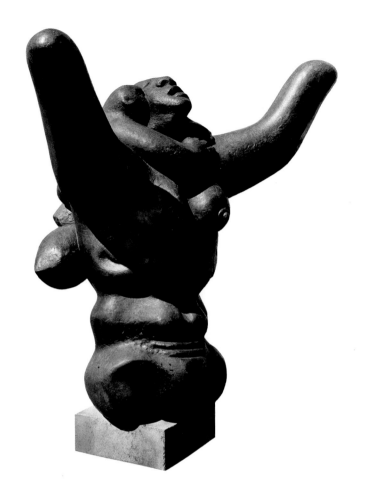

71. Jacques Lipchitz
Mother and child II, 1941–45
Bronze (edition of 7)
127 cm high
Art Gallery of Ontario, Toronto (also: Baltimore Museum
of Art; Israel Museum, Jerusalem; Museum of
Modern Art, New York; Norman MacKenzie Art Gallery,
Regina, Saskatchewan; Philadelphia Museum of Art)

When Lipchitz's friend the painter André Lhote first saw photographs of the *To the Limit of the Possible* series, he identified the connection between these small sculptures and the sculptor's monumental work, and did so in terms of this 'mystical' transformation of material and the fantastic imagery that resulted. Lhote wrote enthusiastically to the sculptor in 1960: "I see here, in another form, the monumental aspect of your work which I have so long admired; it has grown finer, more complicated; it has sprung shoots in every direction; it has indeed flourished thanks to your mastery of technique. You have become the prince of bronze casting The way the greatest Baroque forms emerge here out of the most miniscule detail gives an incomparable sense of original Creation . . . and cosmic energy."[8]

Lhote described how closely he was following the sculptor's work, and how his own painting explored similar ideas, attempting to draw out the

continuity he perceived between their recent artistic investigations and their earlier work in Paris. Here, too, the focus so far has been on the close parallels between the sculptures of Lipchitz's Paris and American years, so as to understand how he could see himself as still a cubist. But distinctions need also to be considered if we are to weigh up the reasonableness or otherwise of Greenberg's influential criticism of the sculptor's post-1930s oeuvre.

As Lipchitz developed a more vital relationship with the materials of bronze and clay, his obsession with spontaneity of technique led to new motifs and working processes. In Paris he had consistently worked through his ideas for sculpture by experimenting with small clay sketches, or maquettes. Many maquettes were later cast in bronze as significant works in their own right, marking out a trail to help trace the path of the sculptor's ideas. From the time when he fled Paris for the south of France in 1940, Lipchitz used graphic work much more extensively and constructively, and for this same purpose of marking the evolution of his sculptural ideas. At the moment war had broken out he had neither the materials nor the will to produce finished sculptures, but he did begin drawing copiously. In America Lipchitz made a conscious decision to work regularly on paper, and in the early 1940s sought out a friend he knew from Paris who was also working in America, the printmaker Stanley William Hayter, to learn engraving techniques from him. Interestingly, at the time Lipchitz first knew him in 1930s Paris, Hayter had been running the celebrated Atelier 17, an experimental workshop for artists of all nationalities, sited at 17 rue Campagne Première in the 14th arrondissement. Here Hayter had developed new methods of engraving which had helped to spread Surrealist ideas of automatism and the unconscious. A background such as this would most certainly have appealed to Lipchitz when in America he was looking for new ways of drawing images out from the deepest levels of consciousness.

Lipchitz became a great devotee of reworking successive proofs of a print with a brush and gouache. His prints were often developed in great detail as stand-alone objects, especially after Lipchitz moved his work-base to Italy in 1963, making frequent use of the Florentine lithography studio Il Bisonte, where he produced varied, colourful, extremely subtle work. Consistently Lipchitz would also use rapid pen-and-ink sketches to try out new themes for sculpture that might be taken no further, but through which he was also

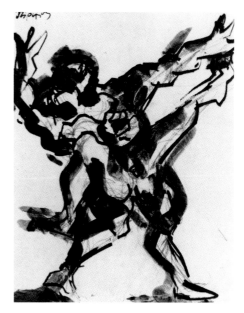

72. Jacques Lipchitz
Study for *Hercules and Antaeus*, 1945
Pencil, India ink and wash on paper
34 × 26 cm
Marlborough Gallery Inc.

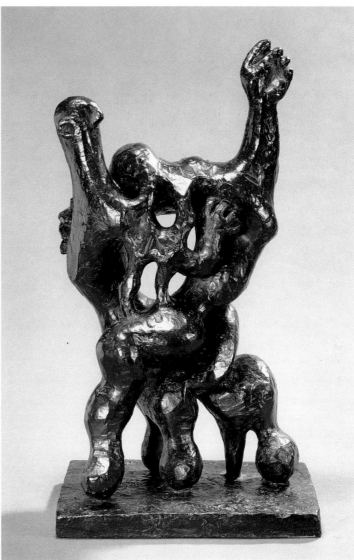

73. Jacques Lipchitz
The joy of Orpheus I, 1945
Bronze (edition of 7)
47 cm high
The Harvard University Art Museum, Cambridge,
Massachusetts (also: Hirschhorn Museum and
Sculpture Garden, Smithsonian Institution,
Washington, D.C.; Washington University Gallery
of Art, St Louis, Missouri)

testing the effectiveness of new compositions. The 1945 Study for *Hercules and Antaeus* (fig. 72) offers one such example. We can see how, once Lipchitz imagined the moment of highest drama as he would depict it sculpturally, as Hercules forces Antaeus' feet off the earth to rid him of his supernatural powers, it must have suggested a type of movement he had not used before. The great release of energy of the figure swept suddenly into the air creates a rocking motion that he imitates in the 1945 sculpture *The joy of Orpheus I* (fig. 73). We can often follow a string of rapid, highly fluid idea-associations as Lipchitz leaps in his mind from one period of his output to another, and

one medium to another, teasing out connections between sculptural ideas through vigorous series of ink, chalk and graphite drawings. So in the early 1960s he recalled the image of Pegasus as he had envisaged it in the 1944–50 *Birth of the Muses* (fig. 75) and he tried out a drawing to see how this figure would sit on a pedestal (fig. 74). As he worked on a further drawing (fig. 76) he casually loosened the shape of the pedestal so that it continued the animated lines of the main figure. This by-product suggested a stack of figures whose arms interlink to form the columnar structure that becomes *Our Tree of Life* in the 1962 bronze study (fig. 77). Lipchitz had made ink sketches of possible sculptures in Paris, but these had been drawn in a more static and heavy-handed way. In America the drawing style changed. The more he practised it, the more accomplished it became, but also the more useful, since by drawing in a freer way he was allowing the line to wander and thus outline the shape of an idea even before it was fully realised.

Scrutinizing these columnar structures, which, envisaged as an ideal format for a public monument, dominated his sculpture for the remainder of his career, one is struck by two marked distinctions between these and the larger of the Paris pieces. The individual sections in *The Government of the People* (see fig. 55), for example, have a softness of form not present to the same degree in the Paris work. This suggests a smooth fleshiness and a sense of being undetermined, as though the hot, fluid metal had not quite set, remaining malleable, slipping readily into new configurations. In this way, even the largest sculptures he made in later life maintain a spontaneity comparable with that of the semi-automatics. The other obvious difference has to do with content. Only in America did Lipchitz compose work that was as 'communal' in structure as it was intended to be in its inspiring, aspirational function, as he began to show whole teams of interlocking human figures rather than the two protagonists that he had preferred before 1941.

The key to Lipchitz's preference for this compact stacking of human form lies with the moral conviction that informed all his work in America, namely his renewed belief that society was in desperate need of some form of spiritual or religious paradigm. He had seen in the totems of native Americans just how striking this piling-up of imagery could be, seamlessly combining aesthetic force with spiritual weight. He also very much had in mind the format of traditional Judaic menorahs. Since meeting his second

74. Jacques Lipchitz
Study for a monument, 1962
Ink and chalk on paper
42.9 × 34.5 cm
Marlborough Gallery Inc.

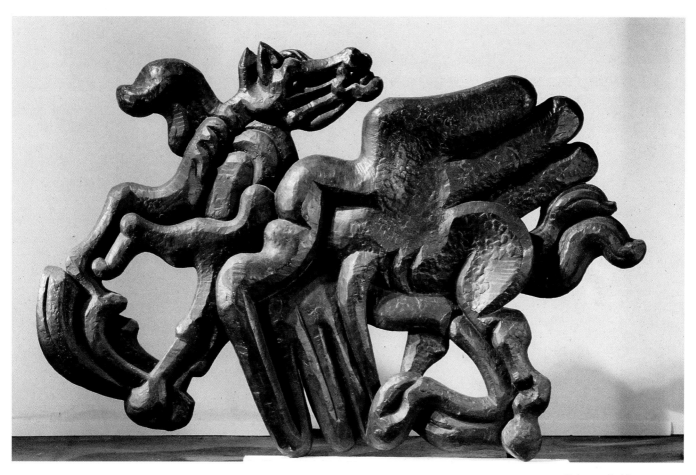

75. Jacques Lipchitz
Birth of the Muses, 1944–50
Bronze, edition of 7
153.7 × 226.1 cm
Marlborough Gallery Inc.

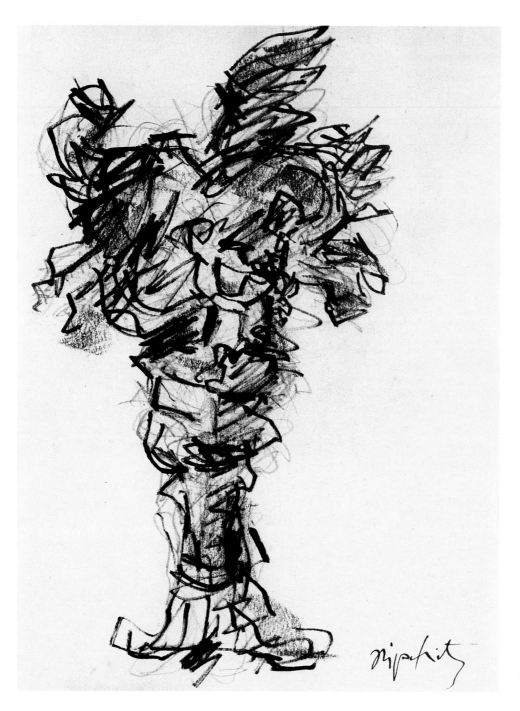

76. Jacques Lipchitz
Study for *Our Tree of Life*, ca. 1962
Felt-tipped pen, graphite and chalk on paper
30.3 × 22.5 cm
Marlborough Gallery Inc.

77. Jacques Lipchitz
Study for *Our Tree of Life*,
1962
Bronze, edition of 7
85.1 cm high
Marlborough Gallery Inc.

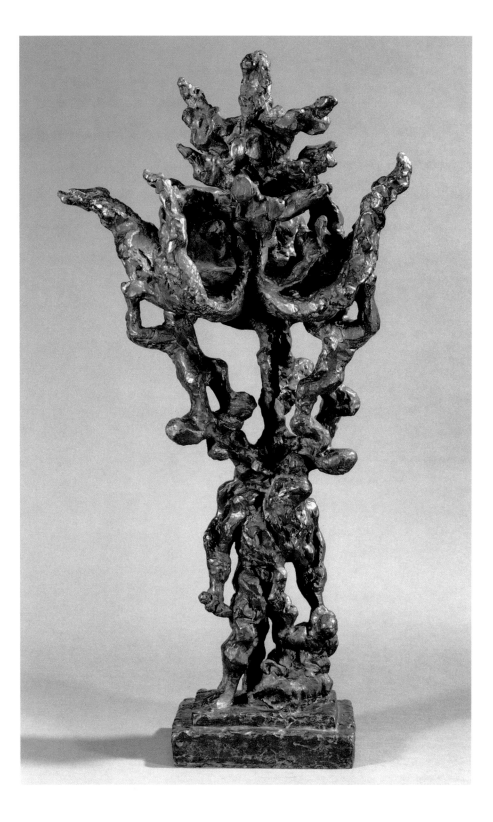

wife, Yulla, in 1944, who had maintained her beliefs from a much more Orthodox Jewish background than his own, he had taken an increasing interest in the political fate of Israel and in the conventions of Jewish Orthodoxy. Along with a conviction that his best means of engaging the interest of viewers of his sculpture was to offer them narrative, this produced work which drew heavily on recognizable religious imagery. Lipchitz described this fusion of secular and Judaic motifs when discussing the sketch for *Our Tree of Life* (see fig. 77), noting: "It is like an Indian totem having to do with the whole development of Judaism."[9]

Within Lipchitz's later work, it is undoubtedly the insistent and highly literal representation of religious narrative which has most irritated his critics, because of the way it draws so heavily on elaborate and complex imagery that can seem narrow and limited, as well as old-fashioned, in its appeal. It can certainly so pre-empt the viewer's response that it becomes easy to lose sight of the structural harmony underlying the careful way in which Lipchitz has built up his forms. In the small-scale work, it can produce genuinely obscure or idiosyncratic motifs that seem to have little bearing on anything other than the artist's personal circumstances and obsessions. Here Clement Greenberg's reservations may seem convincing. Certain sculptures on erotic or religious themes, such as the 1942 *Innocent victim* (fig. 79) or 1947 *Miracle I* (fig. 80) seem to have been conceived almost exclusively as a form of confession and propitiation for the artist. But such instances are rare, and more often Lipchitz's aspiration to the general and 'universal' found in every-day human dramas, together with the great confidence and skill with which he invented new ways of describing the body's energies, transcended even the most specific religious imagery. One example is the story of Hagar, which inspired the fine *Maquette no. 3* of 1948 (fig. 78), an accomplished demonstration of Lipchitz's intuitive understanding of sculptural form.

In the case of the large monumental works, such as the *Pegasus* (see fig. 54), the difficulty viewers may experience in understanding the connection between an elaborate imagery and the artist's highly refined, formal intention can be equally restrictive. Yet by reacting intuitively before responding intellectually to this sculpture, the viewer can appreciate that, in its setting, it works with tremendous force and grips the imagination in an unparalleled way. Lipchitz is deliberately returning to the supreme moments in the history

78. Jacques Lipchitz
Study for *Hagar: Maquette no. 3*,
1948
Bronze
Approx. 21.1 cm high
Marlborough Gallery Inc.

79. Jacques Lipchitz
Innocent victim, 1942
Bronze (unique)
45.7 cm high
The Harvard University Art Museum,
Cambridge, Massachusetts

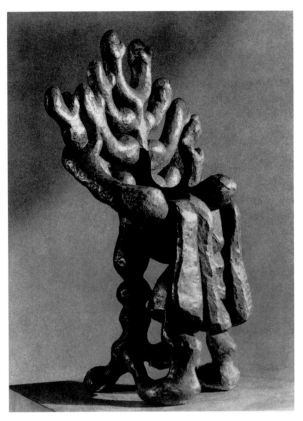

80. Jacques Lipchitz
Miracle I, 1947
Bronze
36.2 cm high
Marlborough Gallery Inc.

of architectural sculpture when the artist could provoke precisely this reaction of complex but profound introspection. A comment made by his most loyal commentator, Waldemar George, is helpful here. It appears in a private letter written to the sculptor after George had seen a major retrospective of his work at the Musée National d'Art Moderne in Paris in 1959. Seeing the whole oeuvre in this way, George realised what he had been unable to see before: "I can at last see the hidden secret of your work, in its formal and dramatic capacity. This is an art that has been constructed in the great tradition of historic public sculpture. Your cubist sculptures appear now like classical masterpieces. Your transparents defy every principle of weight and balance. Your *Song of the vowels* [fig. 81] is indeed a modern version of the Louvre's *Victory of Samothrace*."[10]

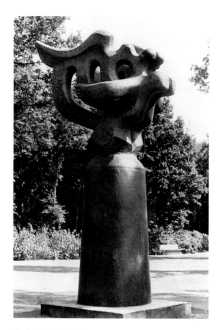

81. Jacques Lipchitz
Song of the vowels, 1931–32
Bronze, edition of 7
396.2 cm high
Art Museum, Princeton University, New Jersey
(also: Franklin D. Murphy Sculpture Garden,
Wight Art Gallery, U.C.L.A.; Kunsthaus Zürich;
Centre Georges Pompidou, Paris; Kröller Müller
Museum, Otterlo, Netherlands; Stanford University,
Palo Alto, California)

82. Jacques Lipchitz
Bellerophon taming Pegasus,
1964–66
Bronze
365.76 cm
Broadgate, London

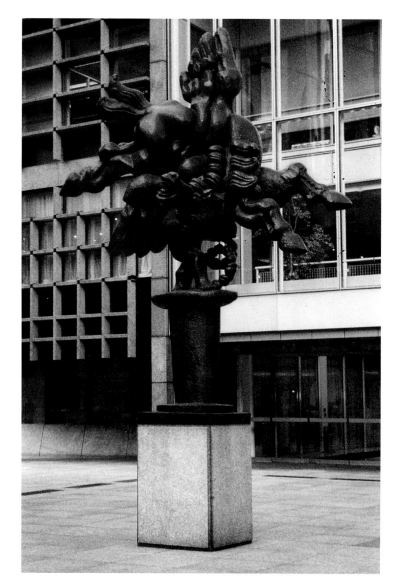

By placing a work such as *Bellerophon taming Pegasus* (fig. 82) in a public plaza or in front of a typically modern, reductive building like New York's Columbia University, Lipchitz is proposing something very difficult for our contemporary sensibilities, namely the shock of a direct bridging of art from different historic eras, as though he had planted a Baroque sculpture in a metropolitan thoroughfare, or were siting Donatello's *Judith and Holofernes* in Times Square. His action is a careful theatrical and intellectual tactic, and it is this that presents us with the 'problem' of Lipchitz's later work. At this

point critics such as Greenberg decided that he had lost his way, while the underlying issue is in fact that, for some, this particular juxtaposition of apparently clashing time-scales, styles and historic contexts was simply not acceptable. To reject this form of juxtaposition is the prerogative of any critic or public, but to attempt to understand it is the more challenging option. This determined historical and architectural proposition was Lipchitz's most daring move. It is up to us, as contemporary viewers, to respond to Lipchitz's prompting and to ask for ourselves how the cultural forms of the past can connect with our multiple presents. We may feel that Lipchitz's invitation is disturbing and open-ended, but if we consider with an open mind the extraordinary range of values, both historical and emotional, with which he confronts us, we may realise something of the scale of his achievement.

1. Clement Greenberg, *Art and Culture*, Boston 1961, pp. 105–10 (essay written in 1954).
2. Jacques Lipchitz with H.H. Arnason, *My Life in Sculpture*, New York and London 1972, p. 197.
3. One of the earliest references to the statement by Leonardo appears in an unpublished letter from Lipchitz to his friend the writer Roger Vitrac, written in January 1928; Tate Lipchitz Archive, File A4. Lipchitz writes: "Let me confess something to you. Since the start of my artistic career, one thing, an opinion, has troubled me constantly. It is that famous remark by Leonardo da Vinci about sculptors and sculpture (in which he evoked the different working conditions of the painter and the sculptor, the latter battling though dust and dirt to arrive at his vision) I realised the extent to which we have been enslaved by our materials, how impossible for our hands to follow the movements of our heart or the wild coursing of our imagination."
4. The exhibition was entitled *Jacques Lipchitz: Fourteen Recent Works 1958–1959 and Earlier Works 1949–1959* and took place 10 November–5 December 1959. A copy of the catalogue and the loose insert can be found in the book library files of Tate Britain. The draft text, annotated by Lipchitz, is letter no. 201 in the new Hastings archive which is discussed in detail in the next section below.
5. Jonathan Fineberg, 'Lipchitz in America', in *Lipchitz and the Avant-Garde. From Paris to New York*, exhib. cat., Krannert Art Museum, University of Illinois at Urbana-Champaign, 2001, pp. 63–64.
6. Roger Vitrac, *Jacques Lipchitz*, Paris 1928, p. 5.
7. Lipchitz with Arnason 1972, pp. 177, 202, 222.
8. Hastings Archive, letter no. 392.
9. Lipchitz with Arnason 1972, p. 198.
10. Waldemar George, unpublished letter to Jacques Lipchitz, 22 May 1959; Hastings Archive letter no. 496.

The Lipchitz Gift to the Courtauld Gallery 2002

83. Lipchitz's studio,
Hastings-on-Hudson, exterior

Lipchitz's studio in Hastings-on-Hudson (figs. 83–87) was purpose-built in 1952 under the direction of a local friend, the architect Martin Lowenfish. A great hangar of a building, some 75 feet long and 24 feet high, perched on a wooded hill overlooking the broad sweep of the Hudson river and its distinctive rust-coloured rocky escarpments, this new space was the ideal setting in which Lipchitz could pick up his career again after the devastation of the New York studio fire. He recalled, "When I first saw it empty of all my sculptures it seemed huge and barren; but it was amazing how quickly it filled up, not only with new works but with older pieces, my plasters, and the rest of my collection that was brought from Paris. Now the only problem is that I do not have nearly enough room."[1]

The Hastings studio, fifteen miles north of New York City, creates, even now, thirty years later, very much the same impression as it would have done when Lipchitz referred to it in 1972 – draped with heavy chains and lifting equipment, scattered with tools, drawings, boxes of exhibition catalogues and letters, the ground a maze of bits of plaster, partial figures and crates containing models shipped from Italy, beside shelves lined with portraits of the many prominent society figures whom the sculptor was called on to commemorate.

The plasters here date from every period of Lipchitz's life, and on his death formed one very important record of the sheer energy and scope of his output. A number have since been selected in representative groupings and given to major collections worldwide, including the Musée Nationale d'Art Moderne in Paris; the Kröller-Müller Museum, Otterlo, in the Netherlands; Tate, London; and the Museo Reina Sofia in Madrid. In 2002 the Jacques and Yulla Lipchitz Foundation are most generously giving some thirty-five plasters

to the Courtauld Institute Gallery, London, a unique group of works that provides scholars with yet a different perspective on Lipchitz and a particular insight into his architectural prowess.

As David Fraser Jenkins and Derek Pullen recorded on the occasion of the Tate gift in 1986, the individual works in these selections fulfilled varying purposes for Lipchitz, and represent different stages in his sculpting process.[2] It will be noted from the Courtauld gift, as we see from the Tate plasters and terracottas, that even to the untrained eye the colours, surfaces and textures vary considerably from one piece to the next in a way that suggests a diverse range of casting and finishing techniques.

Some works are unique plasters from which no bronze will have been cast, acting for the sculptor like the document of a concept worked through in one direction only. Plaster, a stable and durable material that can be coated in shellac to seal its porous surface, was a crucial means for Lipchitz to chart his ideas. To begin, Lipchitz usually modelled a small sketch, building up a figure from little tabs of clay and then defining sections by sharply cutting into the forms. His clay sketches were then frequently cast in plaster (clay, except as terracotta, cannot be preserved by firing), producing works such as the smallest of the sculptures given to the Courtauld. These dynamic little pieces, recording major themes such as that of the *Mother and child* and *The couple*, preserve all the freshness and colour of Lipchitz's original vision and retain the detailing of thumb prints and rough, instinctive incisions. Surprisingly, their energy often gives them as memorable a presence as sculptures ten times their size.

Some of the larger sculptures in the Courtauld gift would have been primary or original plasters, made (again from clay models) specifically to be translated into stone or bronze, and thus a middle stage in a step-by-step, labour-intensive casting process that followed nineteenth-century traditions closely and for which Lipchitz required the technical assistance of a sizeable team of craftsmen. Alternatively these works would have been secondary plasters, duplicates taken as a record of works that might be in bronze or stone, or indeed taken from other plasters. Once established in America, Lipchitz was anxious to have his complete oeuvre thoroughly recorded, and, as we read in his correspondence with his brother Rubin in the next chapter, Rubin helped him assemble a full quota, shipping plasters to America and

84, 85. Works included in the Courtauld selection, photographed in the Hastings studio. In the right-hand lower section of the view below is the 1911 *Portrait of a girl*.

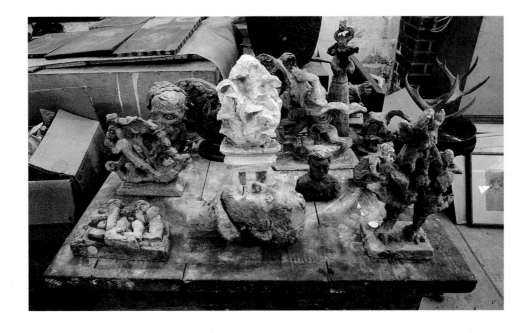

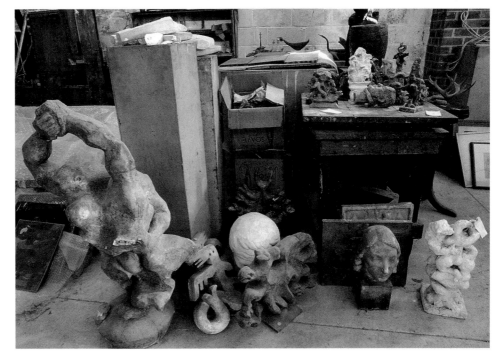

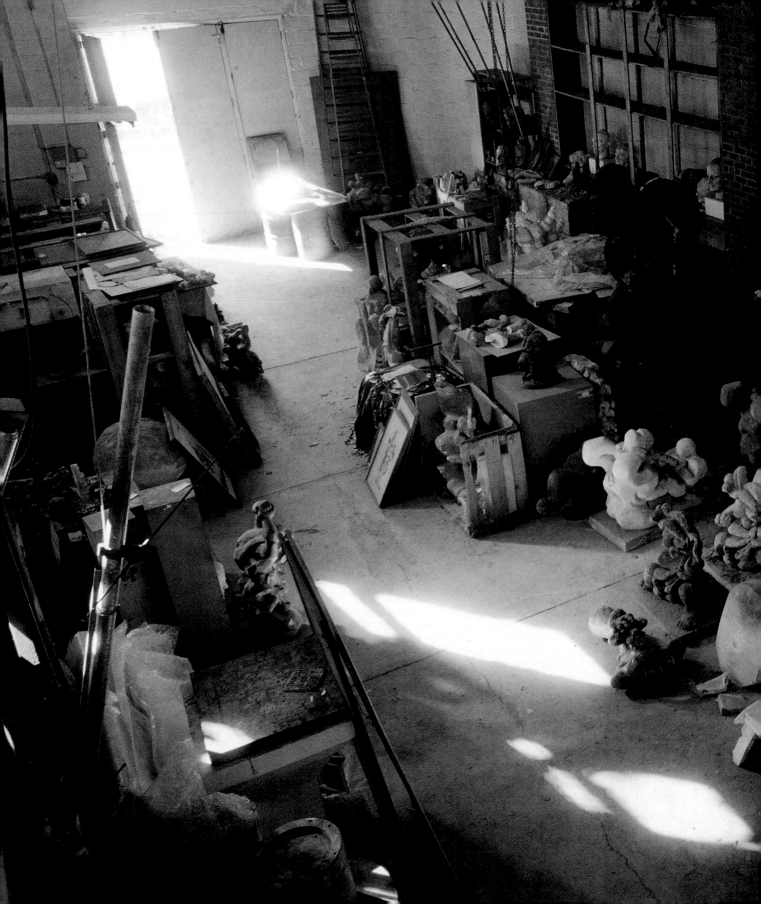

casting bronzes from plasters in France. In America, at some point before 1960, Lipchitz had assembled a collection of plasters of his Paris work and had them in their entirety cast in bronze, then again in plaster. The genealogy of the Courtauld plasters is therefore complex, one which only conservation can unravel, and it stands to remind us just how protracted the process of making sculpture is, and how subtly the expression of ideas might vary between clay sketch, plaster and bronze.

The Courtauld selection ranges in subject-matter from some of Lipchitz's earliest work to studies for his last great monuments. During his first years in Paris Lipchitz produced quite stylized, classicizing, formal compositions, which demonstrated what an instinctive feel he had for conveying the warmth of the human figure. These early experimental pieces are represented in the Courtauld gift by the fine *Portrait of a girl* (see right-hand lower section of fig. 85) and unusual *Mythological scene* relief, both conceived in 1911. In the particular way the figures are simplified and so well balanced, this relief also reveals how fine an eye the sculptor had for the decorative. Some of the most prominent writers on Cubism in the ensuing decades, such as Guillaume Janneau, stressed the degree to which decorative prerogatives lay at the heart of the movement, and the reality of this is brought out well by the Courtauld selection. As we move within this group into the 1920s, and to a major cubist work such as the 1920 *Harlequin with mandolin,* the gift demonstrates how simplification, and rhyming forms and textures, give his sculpture its sense of place and unity. It is this deliberate counter-balancing of different parts of the figure, the self-conscious visual play using the patterns in a costume, and the love of symbol and abbreviation, such as the use of a musical note to indicate a whole score and a context of busy music-making, which make Lipchitz's cubist bathers, musicians and musical reliefs, from 1916 into the 1920s, so effective. These sculptures are at one and the same time 'decorative' and architectural, built solidly, constructed in a compact way as though block by block, designed ultimately to function as well in the outdoors, using deep undercutting to catch the light that gives their forms even greater depth.

As we saw in the second chapter, the first and career-making architectural commission Lipchitz received was for Albert Barnes. The Courtauld gift more than any other selection of plasters displays the nature of the Barnes

(Previous page)
86. The Hastings studio, interior

commission. It also reveals the significant role Lipchitz played for Paris's *beau monde* in the 1920s and 1930s, the fashionable designers and couturiers who wanted Lipchitz's sculpture to be an integral part of their living and working environments. The gift includes five works from the Barnes commission, two full-scale outdoor reliefs (right of centre in fig. 87), two of Lipchitz's earliest maquettes for the Barnes reliefs, and a study for a garden vase. The full-scale plasters played an important promotional role for Lipchitz in 1920s Paris – a set of plaster reliefs for the Barnes commission was exhibited at the 1924 Salon des artistes décorateurs, and in the press at the time it was for his reliefs that Lipchitz was being praised, it was these that were considered his most innovative work. The Courtauld plasters demonstrate just how skilled is the fluid intermeshing of forms in these works, each like its own stage-set

87. Works included in the Courtauld selection, photographed in the Hastings studio

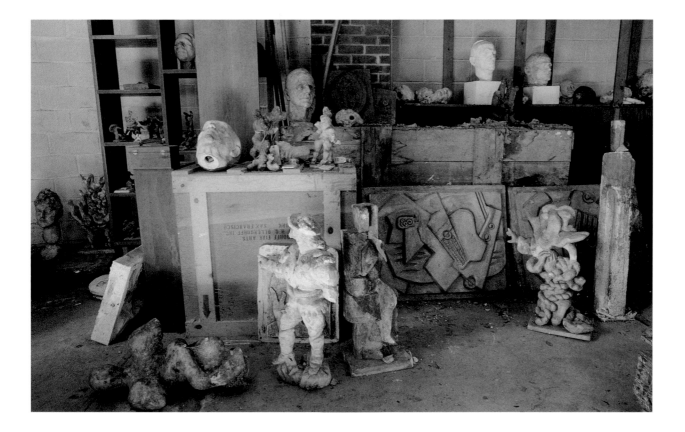

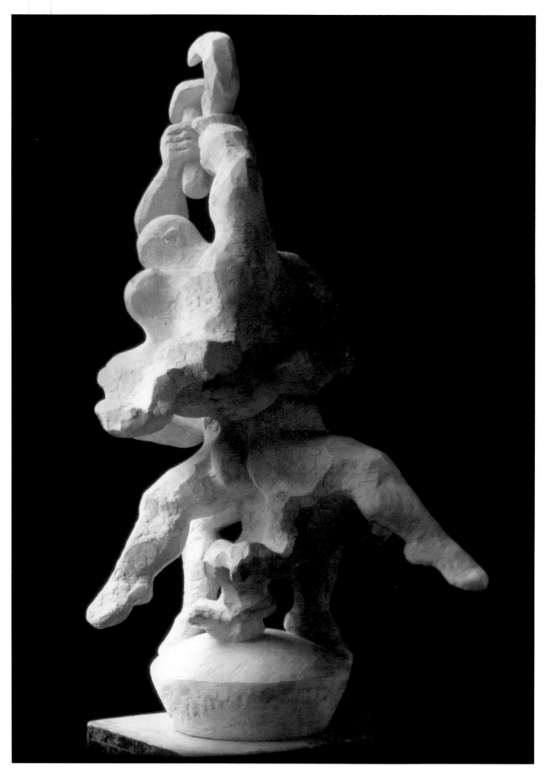

88. Jacques Lipchitz
The dance, 1936
Plaster
Destroyed
These important archive
photographs show a version of
the work incorporating the motif
of hammer and sickle in the
clasped hands.

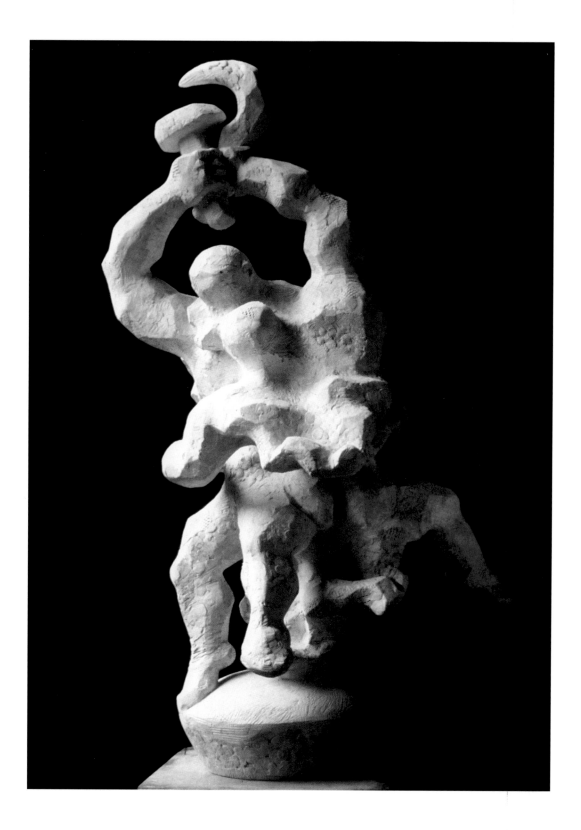

with moving characters, whether a troupe of musicians in rapt concentration, or a still life composed of a bowl of fruit, a book, a clarinet and mandolin floating timelessly in an open, airy space. These works are distinctly cubist, and their popularity shows just how fashionable Cubism remained through the 1920s. In the late 1920s and early 1930s Lipchitz continued to produce cubist work for the Parisian social élite, including the Courtauld's stunning fireplace relief and andiron, made in 1927 for the couturier Jacques Doucet, and the 1932 'mermaid' andirons for Pierre David-Weill, the banker son of a prominent collector.

The bold inventiveness of these sculptures betrays the artist's growing fascination with the mechanics of metamorphosis – abstract forms inviting endless re-interpretation, prompting the viewer to look again and to find, in the fireplace relief for example, at one time a turbulent sea, at another a parade of animals. A fine group of small plasters within the Courtauld selection shows us these processes of metamorphosis at work, from the animalistic figure of a distraught mother clasping her child to her breast (the 1931 *Mother and child;* see fig. 40) to the so-called *Man with clarinet* of 1931 (see fig. 44), also painfully writhing, which looks more like some part-reptile, part-human creature – the product, Lipchitz claimed, of mere fantasy, but which he acknowledged contributed significantly to the formation of the major theme of the *Return of the Prodigal Son* (see fig. 43).[3] As has already been noted, Lipchitz was particularly fond of portraying the encounter, a conflict of two protagonists, often showing a pivotal moment in the action, where the struggle is finely balanced and its outcome uncertain. This theme of the struggle is well represented in the Courtauld plasters, which include an important 1933 sketch for *The embrace* and major full-sized monuments such as the 1933 *David and Goliath* (see fig. 47), and a dynamic plaster of the 1936–37 World Fair *Prometheus* (see figs. 51, 52). The usefulness of a selection of plasters such as this lies manifestly in the opportunity it creates to see side by side Lipchitz's animated little maquettes and the finished monumental work that was the fruition of the sketched idea. We see for example on the one hand one of the sculptor's 1934 studies for a Russian monument, two vigorously twisting figures mounted on a patterned column, and the large 1936 plaster for *The dance* (fig. 88). The later work that was the outcome of the sketch is more 'readable' and we can make out clasped

hands, two heads, muscular limbs, but interestingly it seems more static than the maquette, which intrigues us with its barely distinguishable human forms but which we appreciate for its explosive energy. The quickest sketches, even Lipchitz's meditative portraits, like the two little 1933 *Géricault* heads in this selection, are equally adept at suggesting the flicker of real life beneath the surface.

To return to the crucial architectural qualities of Lipchitz's work, we can appreciate now the sculptor's processes of constructing a mental image of a finished sculpture, allowing a figure to emerge in clay as he built it in his mind, piece by piece, so the forms of the two clasped dancers in his 1930s monument grow as if naturally, or organically, from a fixed centre, moving upwards and outwards into an energized space (see fig. 88). They evolve into what becomes a complex, columnar structure – that format which, as we saw in the third chapter, Lipchitz found well suited his intentions for creating a new type of public monument. Again, the Courtauld gift contains some powerful examples, most notably the 1967 working model for *The Government of the People* (see fig. 55), with its closely meshed structure of human forms, every figure holding and supporting another, pushing upwards together, a metaphor for a society founded on liberal, humanistic principles. Lipchitz had succeeded in his ambition to give his life's work the shape of a carefully structured building capped with overarching and far-reaching human concerns.[4] His motivations were most appropriately encapsulated in imagery of Elie Faure's: "The skeleton's functional logic is such that it suggests to the onlooker the possibility of infinite combinations. Lipchitz brings to us a perfectly conditioned skeleton of a universe to be constructed as a cathedral".[5]

1. Lipchitz with Arnason 1972, p. 193.
2. David Fraser Jenkins and Derek Pullen, *The Lipchitz Gift. Models for Sculpture*, Tate Gallery Publications, London 1986.
3. Lipchitz with Arnason 1972, p. 113.
4. "I am still, like my father, putting one brick after another in the building of a house, attempting to make a final statement. I would like to be able to make this at the end of my life, or, as my father always said, 'to come to the roof'": Lipchitz with Arnason 1972, p. 225.
5. The eminent French historian Elie Faure, who had known Lipchitz since his earliest successes in Paris, writes here in the introduction to the 1934–35 New York Brummer Gallery Lipchitz exhibition catalogue.

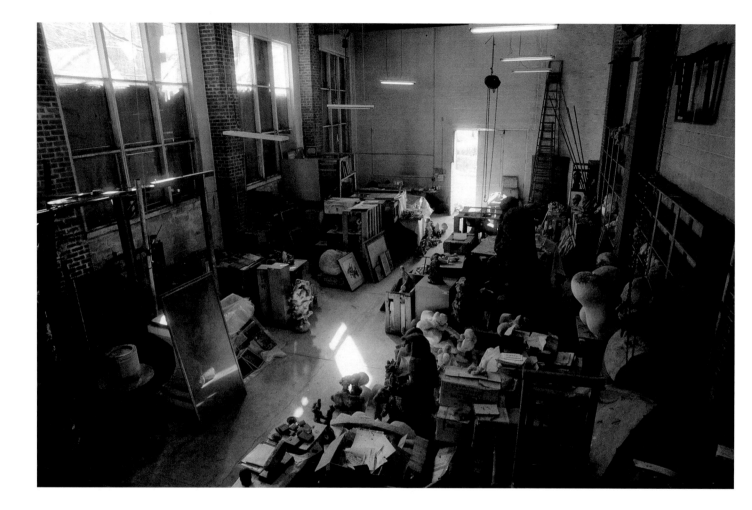

Letters from Lipchitz's Studio

89. Lipchitz's studio, Hastings-on-Hudson, interior

In May 2000, several packing-cases worth of papers were retrieved for the first time from Lipchitz's studio at Hastings-on-Hudson. These numbered well over 1500 items, including letters, cheque books, diaries, press cuttings, financial statements and photographs. The many accounts and statements from dealers, foundries and potential patrons and buyers provide a useful barometer of the market for Lipchitz's sculpture. The papers date from 1950 through to 1968. About half the letters are written in French, half in English.

The most interesting and significant documents are the letters, especially those from Lipchitz's closest friend, his brother Rubin, and from the many people Lipchitz kept in touch with from his years in Paris, including a number of major critics and writers. The American material covers primarily Lipchitz's major public commissions, including detailed correspondence with the White House shortly after the assassination of President J.F. Kennedy, as staff assisted Lipchitz in a nationwide hunt for a presidential lookalike to enable Lipchitz to make a life-like portrait. The project most extensively documented is the Notre Dame de Liesse commission for Iona (Scotland), New Harmony (Indiana, USA) and Assy (France).

This material taken as a whole stands as an important adjunct to the Lipchitz papers in the Tate Archive, London. Its level of academic significance is considerable, as it continues themes from the Tate letters, written when Lipchitz was establishing his career in France. Together, these draw a vivid picture of the struggles of a respected Jewish artist in combating racial prejudice and negotiating the difficult path from producing work for exclusive, art-world markets to addressing a wide and sceptical public.

Selected letters and excerpts from the Hastings archive

Orthography follows the original texts.

Texts by Lipchitz and public statements

(undated) Script for 'Birth of a Bronze'

A sculptor must continue to grow, to find new images that express his ideas. My faith is in the indomitable spirit of man. Every sculpture I make is conceived in a spirit of optimism.

I want my sculpture to give the effect of seeming to turn – to impel the spectator to walk around it. In other words, it is the illusion of movement that I seek.

I was very influenced by Cubism. I am still a Cubist. What I learned from Cubism remains the grammar and syntax of my art. Gradually I became obsessed with the need for a much looser handling of clay – I hoped to find some way of opening up its solid core to penetrations of light and space.

All my life I have read the Bible - especially the Pentateuch. It is not impossible that I associated, subconsciously, Jacob's name with my own. But the real story is for mankind. Man is wrestling with the angel. It is a tremendous struggle, but he wins and is blessed.

I was living in Europe before World War II. The rise of Hitler, the political tensions in France, the fear of war, the great depression – all had their impact in my subsequent sculpture. I sought heroic themes to help symbolize the victory of mankind over these terrible forces.

Perhaps one of my most dramatic sculptures is 'Mother and Child' done in 1941. This is a huge torso, with every muscle flexed, head thrown back, arms raised in supplication. In reality it is a tortured prayer for the salvation of Europe. It wasn't until the sculpture was completed that I discovered the source of the image. It seems that years before I had come out of a theatre in the rain and hearing the voice of a woman singing in a loud, hoarse voice, I traced it through the darkness until suddenly she appeared under a street lamp, a legless cripple in a little cart, with both arms upraised and with her wet hair streaming down her back as she sang.

In the museum you see five clay sketches for 'the Virgin' – a sculpture I was commissioned to do for the church in the mountain village of Assy, France. The image was slow in coming, but one day as I was riding in the subway the idea for the virgin came. I pulled out a pocket notebook and began sketching: here stands the Virgin Mary, her palms spread towards the earth, while beneath her are three archangels and the lamb. Overhead flies the dove of the holy ghost, plucking in his beak the three parts of heaven which form a starry canopy.

The first model was destroyed in a fire at my studio. It was a severe blow, but the fire stimulated a fresh stream of ideas and images.

In the casting of my sculpture, I use what is known as the "lost wax" method, dating back to antiquity. I model the original in wax without any armature. At the foundry, a plaster mould containing a network of ducts is built around the figure so that the wax when melted can be drained off. Molten metal is then poured into the space left by the "lost" wax.

On the back of the virgin statue is inscribed the following – "Jacques Lipchitz, Jew, faithful to the religion of his ancestors, has made this virgin to foster understanding between men on earth that the life of the spirit may prevail".

Jacques Lipchitz

IMMEDIATE RELEASE

April 28 1964

THE WHITE HOUSE

President Johnson announced today that the internationally famous sculptor Jacques Lipchitz will design the medallion to be presented to the Presidential Scholars in June.

In making the announcement, the President said, "Jacques Lipchitz is one of the great sculptors of all time. I am happy to announce that he has agreed to design the medallion. The medallion will honor excellence, and we are now assured that it will be conceived in excellence."

Lipchitz, a sculptor of renown for half a century, maintains his studio in Hastings-on-Hudson, New York. He has lived in the United States since 1941, and has been a citizen since 1957.

Born in Lithuania in 1891, he moved to Paris in 1909 to study sculpture. Except for a short time in Spain, he lived in France and became a French citizen until coming to the United States.

Lipchitz first became known as a sculptor of the Cubist movement. He is also noted for such later epic works as "Prometheus Strangling the Vulture", the "Spirit of Enterprise", and the "Virgin of Assy." His portraiture work includes busts of Gertrude Stein, Jean Cocteau, and, more recently, the late Senator Robert A. Taft.

From the sculptor's brother, Rubin, to Lipchitz

(i) 20 January 1954

Rubin refers to Lipchitz's Paris home at Boulogne-sur-Seine, where Lipchitz's first wife, Berthe, still lived, and where many sculptures and artefacts in Lipchitz's collection were left when Lipchitz emigrated. Lipchitz by 1954 had married his second wife, Yulla, by whom he had one daughter, Lolya.

Mon frerot,

Je pense, que très bientot une deuxième bonne nouvelle pourra-t-être annoncée. J'ai promis au Directeur du Musée du Havre (qui a été completement detruit pendant la guerre et est en voie de reconstruction) l'amener à Boulogne. Mon impression, qu'il s'interesse au grand bas-relief. Peux tu le vendre, combien? Mais de mon coté, je tâcherai le diriger sur le grand Promethée et aussi à tout hasard, s'il te plait le prix!

Guillet m'a envoyé à signer le papier pour le reglement du buste [. . . .] Il est interessé par le grand 'Vers un Monde Nouveau'. Es tu libre de le vendre et si oui, combien? Celui-ci je suis à peu près sûr de pouvoir placer au Musée de Rouen. Ceci est d'autant plus interessant, que le conservateur veut en faire de ce Musée comme il m'a dit lui-même: 'un joyau des Musées de France'. Avec une collection à la base, qu'ils possedent deja, l'ambition est bien justifiée [. . . .]

Ta lettre concernant la 'Femme à la Tresse' (il existe un bronze à Boulogne) le Marin et Guitare et 'les instruments de Musique' est arrivée après que tout

a été enlevé de l'atelier. L'envoi par lui même est deja assez volumineux et ces plâtres etant moins pressés, je te les enverrai à part prochainement [. . . .]

Je suis content que tu as rencontré Arbit. Jusqu'à présent tu m'as pas dit, si tu as réçue la 'Danseuse' et 'la Liseuse' et comment trouves tu les toutes [. . . .]

Merci pour le dessin de Lolia. Oui, elle fait des progrès. Embrasses la bien fortement de ma part. Longtemps sans nouvelles de Yulla. Vous tous je serre fortement sur mon coeur. Portez vous bien.

Zaït Gezound, Ton Rubin

(ii) 12 December 1954

Discussions are underway with Jean Cassou at Paris's Musée d'Art Moderne regarding the possibility of mounting a Lipchitz retrospective in 1956.

[. . .] Ton oeuvre, tu arrives à la mettre à sa place. Il n'est pas exclu, que Cassou ne se rendant compte qu'on ne peut plus l'étouffer, voudrait rattraper le temps perdu et ne pas rester en queue par rapport aux autres – de même Curt [Valentin] – pour d'autres raisons – Comme je disais à Cassou pendant longtemps, des forces occultes t'empechaient de respirer librement [. . . .] Il faudrait couler tout ce qu'on peut ici – cela couterait moins que le transport et on aura des bronzes.

(iii) Undated (1958 from postmark)

[. . .] Maintenant parlons affaires. Encore une fois de plus, je te repete que tu ne te rends pas compte combien d'un coté ton oeuvre est·ignorée en Europe et d'autre part combien de forces occultes et puissantes travaillent contre toi [. . . .] l'exposition d'Amsterdam est magnifique; elle a été organisée comme on ne peut mieux [. . . .] Nous avons surpris tes ennemis – la presse elle même en temoigne [. . .] les expositions à venir doivent être sans faille et seulement lorsque le tout sera consolidé, quelques livres et etudes en profondeur le sanctionneront, des sculptures placées dans des grands musées, à ce moment tu pourras dire Ouf! [. . . .] Or ce silence en France doit être brisé à tout prix.

(iv) 12 June 1959

Mon cher Jacques,

Les nouvelles de l'exposition sont bonnes. Malgré le très peu de réclame qu'ils font, le nombre des visiteurs augmente chaque jour et en ville, on en parle avec passion. La moyenne des entrées est bonne parait-il – ceux que cela interesse vraiment y sont allés et même revenus. La presse est pas abondante – mais toute favorable. Cognat a fait un très bon article dans le 'Jardin des Arts' avec beaucoup de reproductions. Maintenant m'arrivent des échos de province [. . . .]

Tu me demandes tout le temps comment vais-je m'organiser [. . . .] Mon premier objectif est d'amener toute l'exposition à Londres – après nous verrons plus clair le reste. Mais tu pourrais m'aider beaucoup en me disant et en éclairant ma lanterne concernant tes projets à Boulogne. Comment veux tu que cela s'organise là bas [. . .]?

Tu me dis que Hope est en train d'écrire un livre sur toi et c'est pourquoi je suis obligé de revenir sur l'article que Otto [Gerson] a organisé dans l'Oeil. C'est la seule chose qu'il a faite pour l'exposition, la seul depuis le debut [. . . .] Il est tombé [. . .] avec bruit et en éclaboussant. Mal écrit, horriblement traduit, sujets hors propos et d'une tenue générale dont ton oeuvre mérite mieux.

Je te dis, brouderre, ceci non pas pour ou contre Otto, mais pour le futur livre de Hope. Il y a un standing à tenir – des compromis dans ce domain sont graves et mènent loin. Il y a quelque chose de morbide chez Hope. Il faut qu'il nettoie son texte de toutes les histoires de faillite et de ta mère derrière une table de Kretchmé, de cette atmosphère de guetto dans laquelle nous n'étions jamais à Druskieniki. Ton art a un caractère d'universalité et non pas, je ne sais quel gout juif. Toi, tes frères et soeurs ont réçus une éducation universitaire [. . . .] Ta arrière grande mère ravitaillait les Povstancy – qui luttaient pour la liberté – notre maison était une respectable maison bourgoise, notre mère était croyante – mais liberale même sur ce terrain envers ses enfants.

Un livre, qui est un document, qui reste pour longtemps, doit au moins lorsque cela depende de toi être dirigé. Il y a tant de Beauté à chanter sur le Niemen et les Forêts de chez nous, sur la nature et la santé de sa population, sur l'amour de tes parents et de tous les tiens, sur Paris dès les années 1909

[. . . .] Pourquoi diable a-t-il besoin de se psychanalyser à travers toi. Ton oeuvre ne suffit-il-pas?

Et cela me ramène encore au sujet d'un livre par Cassou. Le seul bien fait jusqu'à présent est le dernier Raynal. Oui, au point de vue materiel il a été pas brillant. Mais il n'a pas été fait pour faire une affaire. Dans tous les Musées existe un exemplaire – les principales bibliothèques et ceci est important – le reste est secondaire, oublié depuis longtemps et ne compte plus. Et pourquoi le Raynal est bien – parce que j'avais tout le control dessus. Pourquoi ne pas le recommencer avec Cassou? Quoiqu'il en soit – surveilles de près celui de Hope. C'est trop important et il serait vraiment dommage qu'il devient la source d'inspiration pour la suite loin de la réalité et le climat de ton enfance. A part cela rien de neuf. Je croyais t'avoir envoyé la lettre de Dina et voilà que je la retrouve. Brouderre, soignes toi, je t'embrasse bien tendrement.

Zaï Gezound! Ton Rubin

(v) 22 December 1964, on the subject of a book project on the transparents, which Rubin refers to as "le Grand Morceau" (which sadly was never completed)

[. . .] C'est en très bonne voie [. . . .] Nous avons convenus avec Sandberg que c'est lui en principe, ou avec un écrivain de ses amis, qui le termineront et signeront. Pour ma part je leur prépare tout le materiel, photos, arguments enfin tout le travail préliminaire [. . . .] Fry est ici, je suis très bien avec lui, il m'a même aidé de prendre des photos d'après photos [. . . .] J'ai vu l'avant projet de son bouquin sur le cubisme – cela ne me parait pas une révélation. Il s'attache à la technique et forme, mais ne comprend pas l'esprit. Enfin c'est sont [sic] ses affaires à lui.

(vi) November 24, 1967, to Yulla Lipchitz

[. . .] les Transparents qui sont une véritable révolution dans la sculpture, de la philosophie de la sculpture, une corrolaire dans la sculpture de ce que Freud

a fait pour le cerveau humain. Jacques a introduit cette nouvelle dimension dans son oeuvre dès 1925 [....] [Rubin is not keen on having Hammacher as possible author of a book on the transparents, and goes on to explain:] Son approche est trop doctrinaire. Je crains que le but sera difficilement atteint par lui. De ce livre, il faut que vous vous occupiez par vous même. Ici, je pense, qu'une solution qui ne serait mauvaise, serait une oeuvre collective (avec un psychoanaliste qui puisse mettre en evidence le parallèle entre le langage de la parole vivante et la parole 'inerte' de la sculpture) sous la conduite de quelqu'un, un grand nom dans la vie des Arts, comme par exemple Sandberg [. . . .] Son rôle serait de dégager les larges lignes de la pensée conductrice en laissant le principal d'exprimer aux photos.

From writers and critics to Lipchitz

(i) 20 January 1952, from the art critic Maurice Raynal

Mon cher Jacques,

Nous apprenons Germaine et moi par Berthe la nouvelle de la catastrophe que tu viens d'éprouver et qui nous consterne comme elle consternera tous ceux qui sauront mesurer l'immense perte que comme toi ils auront tous subie. Il va falloir que une fois de plus tu fasses appel à ce grand courage que ton oeuvre incarne et qui ne t'a jamais fait défaut à aucun moment de ta vie. Je suis sûr que tu triompheras de ce mauvais coup de sort tel qu'en éprouvent les plus grands et comme tu en as vaincu d'autres. Mais crois bien qu'en ce moment je suis profondement avec toi.

Ton Maurice Raynal

(ii) 5 January 1956, from the art critic A. M. Hammacher. Hammacher writes to Rubin here.

Cher Monsieur Lipchitz,

J'ai bien reçu votre carte et je me hâte de vous souhaiter un bon 1956. Depuis quelques mois j'ai dû vous écrire, mais tant d'évènements m'empêchent de trouver le bon moment, que maintenant je dois m'excuser auprès de vous et votre frère pour un si long silence.

Le cas est que je suis navré de la suite de nos projets pour Arnhem et pour le comité Rembrandt. A Arnhem le gouvernement a hésité, quoique les membres, qui avec M. Vegter l'architecte et moi généralement discutent les propositions, voudraient bien aller à Paris pour le Chant des Voyelles. La séance plénière s'est néanmoins opposée à cette idée parce qu'on craindrait beaucoup de difficultés de la part de l'opinion publique. J'ai fait de mon mieux pour obtenir une autre décision, plus favorable, mais pour le moment sans résultat. J'ai seulement empêché l'achat d'une médiocrité. Maintenent on a heureusement rien fait et j'attends seulement le moment plus favorable. Pourtant j'en suis navré.

Le sort du comité Rembrandt est pire. Quoique le comité était vraiment enthousiaste pour la participation de votre frère pour le projet d'un monument, l'action pour fournir l'argent nécessaire pour couvrir non seulement les frais du monument mais aussi tout un plan éducatif pour les écoles et la célébration de Rembrandt, a éprouvé plusieurs obstacles. C'était enfin une grande déception pour nous que la section financière a échoué, tel que j'ai demandé de me retirer de ma position de président de la section de l'art.

On manque donc l'occasion d'un témoinage de notre temps pour Rembrandt. J'espère que votre frère et vous ne m'en voudrez pas.

Veuillez croire, cher Monsieur, à l'expression de mes meilleurs sentiments.

A. M. Hammacher

(iii) 22 May 1959, from the art critic, and Lipchitz's close friend, Waldemar George

. . . [Je viens de visiter] votre admirable exposition au Musée d'Art Moderne. C'est pour la première fois depuis l'exposition de la Renaissance que je me trouve en face d'un ensemble aussi important et aussi significatif de vos sculptures. Cet ensemble qui a été accueilli par le public, par les jeunes artistes et par la presse avec un véritable enthousiasme. Je regarde avec des yeux nouveaux. J'en perçois le sens secret: le sens plastique et le sens dramatique. Un art essentiellement (construit) dans la grande tradition de la statuaire mondiale. Vos figures cubistes acquèront un caractère classique. Vos transparents défient tous les principes de l'équilibre et de la pesenteur. Votre Chant de Voyelles est une version moderne de la Victoire de Samothrace du Louvre.

(iv) 3 October 1963, from the art historian Edward Fry

Edward Fry writes here to Rubin. Rubin had befriended Fry in Paris, and hoped that Fry would help him compile a complete catalogue and analysis of Lipchitz's sculpture.

[. . .] J'ai vu Mme. Barnes récemment, un être très agé et très difficile, avec les préjugés de son marie [sic] contre Jacques, mais sans aucune base en vérité. Elle m'a montré une chemise de correspondance entre Jacques et Barnes – une bonne cinquantaine de lettres de Jacques, du plus haut intérêt. Comme toujours, Jacques avait raison [. . .] j'ai tout regardé et vu que le comportement de Jacques était sans reprendre, qu'il a parlé profondement sur ses idées et sur son art; et que même après la rupture, il restait gentil, même jusqu'à inviter Barnes, très poliment à sa grande exposition de 1930!

(i) 8 January 1952, from the art historian Walter Pach

Cher Lipchitz,

Devant votre malheur, dire que j'en suis navré, désolé n'est presque rien dire. Mais je ne suis pas accablé, et j'ai bon espoir que vous ne l'êtes pas, non plus. Car la perte, si grande qu'elle soit, n'est pas irréparable; vous avez vu d'autres désastres, et vous en êtes sorté triomphant – comme vous le serez cette fois.

J'ai téléphoné à John, chez Curt Valentin, pour avoir des nouvelles. Elles étaient mauvaises plus mauvaises que celles pour lesquelles je m'étais préparé. Pourtant, je lui ai raconté une conversation que j'ai eu avec Claude Monet en 1907. J'avais dit au magnifique veillard que Sargent, qu'il avait connu pendant la jeunesse brillante de l'Américain, avait résolu de ne plus peindre que pour lui-même, pour l'art, et qu'il refusait toutes les commandes de portraits. Monet répondait simplement "Ce n'est pas trop tard?" Et voilà la question qu'on ne peut pas poser dans votre cas.

Après tout, qu'est-qui résulte du travail d'un artiste? Ses oeuvres – oui, bien sûr: mais ce qui compte davantage c'est le developpement de son esprit. Celui de Sargent était corrompu: il était incapable de faire de bonnes choses. Et vous êtes incapable de faire de mauvaises choses. Donc, tout désolé comme je le suis devant cette catastrophe, j'ose vous rappeler que des milliers de personnes, d'artistes même, peuvent encore vous envier.

Et comme me disait Claude Monet à la fin de cette même visite que j'ai mentionnée – "Bon courage! Bon travail!"

Et à bientôt mon cher. Tous nos bons souhaits chez vous (Nikifora se joignant avec ferveur à moi pour tout ce que je vous ai dit – ou ce que j'aurais voulu vous dire).

Bien cordialement –

(ii) 13 May 1954, from Lipchitz's dealer, Curt Valentin

Dear Jacques,

This letter is to confirm our agreement which we concluded yesterday and which will go into effect on June 1, 1954:

1. Every year I shall buy sculpture and drawings amounting to $12,000 payable in two monthly installments of $500 each ($1000 every month) All sculpture and drawings here on consignment which I sell I will receive a commission of one-third (after the deduction of production costs). I shall receive the same commission in case of sales you make yourself in your studio.

2. You have the right to sell drawings in your studio on which I shall not take any commission

3. I shall receive 15 per cent on commissions for portraits, sculpture for buildings, etc., in case I am instrumental in getting you the commission. If you yourself are instrumental in getting a commission of the same type, I shall receive 10 per cent

4. I am obliged to submitt (sic) every three months a list of all sculpture and drawings which I have on consignment

This agreement is valid for three years and will be renewed automatically except if you or I cancel it.

Sincerely yours –

(iii) 17 October 1958, from the painter André Lhote

[. . .] Je conserve farouchement les études que j'ai fait, enfin de mieux remâcher mon passé. Cher ami, je vous suis de loin avec affection et je salue fréquemment des oeuvres de vous, souvent bien loin, comme ce haut relief à Rio de Janeiro, qui jaillit d'un grand mur nu avec force et majesté [. . .] sachez que rien de vous ne me laissera indifférent.

(iv) 8 November 1959, from André Lhote

Mon cher ami,

Votre lettre du 28 oct. m'a fait grand plaisir, aussi que l'annonce de votre
prochaine exposition. Je comprends que vous auriez éprouvé le désir de vous
reposer après l'effort requis par une telle manifestation. On n'admirera
jamais assez l'énergie des sculpteurs qui même au moment de leur triomphe
ont encore à se colleter avec la matière (alors que nous, peintres, lorsque
nous avons cloué un cadre, nous sommes éreintés!)

La secrétaire de M. Gerson est passée à l'atelier dernièrement et nous
avons naturellement parlé de vous et de votre vaillance: c'est magnifique
et j'espère que les américains sentiront la force de votre oeuvre, présentée
dans un cadre que j'imagine magnifique [...]

Mademoiselle Kramer découvre l'art nègre en ce moment et, éblouie par
mes collections, compte sur moi pour lui trouver des échantillons de qualité.
Intellectuellement, l'esprit de synthèse hérité de ces grands sculpteurs la
passionne dans la sculpture moderne, quand celle-ci veut bien échapper à
"l'informel", cette maladie du moment qui ravage les ateliers particuliers
(Et c'est bien démoralisant pour l'auteur des Traités du paysage et de la
Figure). Mon cher Jacques, je vous souhaite de tout coeur le succès que vous
méritez et la fin de vos alertes coté santé.

Les bons souvenirs de ma femme et toute ma vieille amitié –

(v) 24 December 1959, from Willem Sandberg, Director of the Stedelijk
Museum, Amsterdam, on the subject of Rubin

[...] il restera toujours bien lié à vous et rien au monde pourrait y changer
quelque chose – c'est d'ailleurs un lien naturel, parce que pour lui vous jouez
le rôle du père. Seulement la plupart des hommes accepte que le père leur
aide pendant la jeunesse – mais accepte avec plus grande difficulté que le frère
ainé leur porte cette aide nécessaire. Chez rubin cette relation avec le frère ainé
risque toujours de devenir maladif [...] [and regarding Rubin's efforts to place
his brother's work in museums in Europe] [...] les prix américains sont souvent

prohibitifs pour les musées européens et rubin sait traiter d'une façon très amicale avec mes collègues, dont il est bien apprecié.

(vi) 2 January 1960, from André Lhote on seeing Lipchitz's *To the Limit of the Possible* series

[. . .] Le coté monumental auquel j'ai si longtemps applaudi s'est amenuisé, compliqué, a poussé des tiges, en tous sens et a fleuri grâce à une technique où vous avez acquis une maîtrise singulière. Vous êtes devenu le prince de la cire perdue [. . .] et la nature [est] retrouvée tout entière [. . .] un univers de [. . .] gouttes de rosée. Le baroque poussé dans le domaine de l'infiniment petit donne à tout cela une atmosphère de création du monde qui est admirable.

J'espère que les americains ont été sensibles à cette qualité et que votre exposition a eu l'accueil qu'elle mérite.

Une fois de plus, j'applaudis à votre activité, que la mienne reflet à sa façon en demandant à la couleur ce que vous demandez à la torsion cosmique de vos tiges et à l'epanouissement des feuilles au soleil.

(vii) 13 January 1960, from Gabriel White, Director of Art, Arts Council of Great Britain, regarding Lipchitz's Tate exhibition

[. . .] The exhibition, which was among the largest collection of sculpture to be shown in London in the present century, was seen by 8,414 visitors in all.

(viii) 21 October 1960, from Pierre Dubaut

Lipchitz throughout the 1950s and 1960s maintained a discreet business as a dealer in paintings in collaboration with Rubin and Pierre Olivier Dubaut, a picture restorer based in Paris. Lipchitz himself was a great collector, and he and Dubaut regularly compared notes about exciting new finds.

[. . .] Thomson m'a confié sa fameuse et merveilleuse grande nature morte où il y a, à côté d'une brioche et d'un panier de figues, une planchette sur laquelle posent 5 ou 6 pêches veloutées qui sont le plus extraordinaire morceau de

peinture que j'aie jamais vu – Velazquez seul, ou Goya auraient pu exécuter cela avec une pareille liberté et en même temps une telle soumission à l'objet – comme c'est loin des natures mortes hollandaises des David de Heem et autres, pourtant bien belles, mais qui sont plutôt des tours de force de métier [. . . .]

Une nouvelle: les grandes ventes n'auront plus lieu à la galerie Charpentier, mais au Musée Galliéra en face le musée d'art moderne [. . . .] Les prix des tableaux continuent à monter follement, surtout naturellement ceux des modernes. Les anciens au contraire, Delacroix lui-même, à de rares exceptions, sont très peu demandés – tout est spéculation et mon photographe m'a dit avoir eu chez lui 2 Vlaminck à vendre 16,000F chacun.

(ix) 20 December 1960, from the photographer Bert Van Bork, who worked with Lipchitz and who describes a visit to Picasso

[. . .] Then he had the picture of the huge sculpture for Philadelphia in his hand and he was tremendously impressed with it [. . . .] He studied each photograph for a long time and it seemed that the old memories came back to him. Especially the photos of your sculpture he studies intensely and silently. I could see that he was very impressed by your work. In his own words he said the photographs are "noble and human."

(x) 14 April 1961, from the painter Amédée Ozenfant

[. . .] Je pense à vous bien souvent; je vous revois dans votre atelier rue du Départ – ou quelque chose comme cela, puis celui Bd. Ed. Quinet, puis à Boulogne, puis Washington [. . .] et puis à l'inauguration de votre atelier d'Hastings [. . .] que de stations, que de souvenirs, de bons, croyez moi. Portez vous bien, travaillez bien.

Votre terre-cuite ennoblit mon hall.

J'ai dû réorganiser l'horaire de mes journées pour pouvoir mener à leur fin mes deux "bâtiments": je me lève à 4h et j'écris jusqu'à 9h (il est 4:30h maintenant, tout est silencieux, les oiseaux du parc dorment) et je suis en

plein souvenir, comme si le passé était présent) – à 9h breakfast – et peinture jusqu'à plus soif, vers 5h.

J'ai dû adopter cette voie monastique, car ma peinture se vend maintenant avant d'être faite – et je veux pouvoir publier d'ici un an ou deux mes mémoires: *Tour de Vie*.

Pas de projets de voyage en France? Je vous reverrais avec joie, vous, votre femme, la famille, mon vieil ami.

Marthe vous embrasse tous, et moi aussi –

(xi) 11 August 1961, from Amédée Ozenfant

Cher Jacques,

Nous revenons de Paris où nous avons passé une quinzaine. J'ai visité le nouveau musée d'art moderne de la Ville de Paris – qui, vous le savez, fait pendant au musée national. J'y ai revu avec plaisir salle II reservée à la sculpture votre taille directe 'Personnage assis' et la 'Danseuse' 1913. Et dans la salle X, celle des cubistes, voisine de la mienne, XI – votre peinture pour un bas relief à centre rond, 1921 – sur bois. Cela a réveillé bien des souvenirs, je devrais dire *revitalisé*, car je n'ai rien oublié de ces époques de formidable vitalité.

Ce musée est tout neuf, dans l'ancien building, et fort bien présenté dans des locaux remodelés.

Je suis très bien représenté par trois peintures (et bientôt par une de mes grandes 'Murales' puristes) et un bronze. Le bronze, vous le connaissez: c'est 'L'Amour' de 1932 – qui était fixé au mur du bureau de mon école de New York; j'en ai commencé une édition à 10 exemplaires, trois sont vendus. A ce propos j'ai vendu toutes les peintures que je voulais vendre: Il semble que le tachisme (et consorts) perd de sa popularité – c'est devenu une ennuyeuse banalité.

J'ai vu dans Time, en fin août, que vous avez donné à Israël vos platres originaux – ça sent le musée Lipchitz à Tel Aviv. Dans la photo qui vous montre au pied du grand Promethée étranglant le vautour, vous donnez l'impression vouloir poignarder Billy Rose, qui heureusement n'est pas un vautour, vous retient.

Affectueusement à toute la famille –

(xii) 17 December 1962, from the poet Juan Larrea, Cordoba, Argentina

[. . .] Votre histoire de Michel Ange me ravit. Mais pourquoi parlez vous de la folle jeunesse lorsque c'est le creuset de notre sagesse la plus grande? . . . 'L'Ange Michel', celui du 'Jugement dernier' est là d'une façon d'une autre, comme dans votre 'Vierge'.

[. . .] Je crois que, à votre place, j'essayerais de vendre la tête d'Hercule à un grand Musée, puisqu'elle est épaulée par le livre de Pappini et peut être aussi par l'autorité de Venturi. Formidable si elle pouvait être acceptée, même avec une interrogation, par les experts, et presentée au public dans une grande salle. L'histoire finirait en toute beauté, prenant état dans la conscience générale. Plus tard, peut-être bien plus tard, viendraient mes écritures, j'espère, avec tous les détails qui demontrent une fois de plus l'existence en opération d'une Realité qui "parle". C'est au fond notre grande raison d'être.

(xiii) 14 March 1963, from the artist Boris Taslitzky writing from Paris

Bonjour, Mon cher maître. Je t'écris de cet atelier de la rue Campagne-Première, où la lumière est toujours aussi maussade, les murs lèpriés d'humidité, là où vieillit le jeune homme que tu as connu, dans un monde où tu manques beaucoup à l'évolution de son travail qui, hélas, te decevrait beaucoup, je le crains. De loin en loin, je fais un dessin convenable et je pense, "pour celui-là, il ne me batterait peut-être pas le cul." Quoi-qu'il en soit, je travaille sur mon registre si restreint soit-il et je bois dans mon verre.

Au mur, il y a ton dessin. Tu t'en souviens sans doute, c'est une étude pour "la joie de vivre dans un monde nouveau." Il est resté dans son encadrement original. Ce matin, j'ai peint dans la séance un portrait de Robert qui me donne souvent de tes nouvelles, de celles des tiens, qui est fier comme un paon de sa nièce. Cet après-midi, nous sommes allés à Boulogne chercher le plâtre de P.V-C qui à cette heure est dans mon atelier. Je t'en remercie, comme tu le penses.

J'ai revu avec émotion tes deux ateliers, la lumière y est belle, mais le vide qui a laissé l'absence trop definitive du Patron, m'a rendu tout triste et plein de l'amertume des regrets inutiles. J'ai été cependant heureux, d'y voir toute

la collection des moulages de plus de cent esquisses qui toutes me remettaient dans le bon bain des créations véritables.

La dernière fois que tu as mis le pied dans montmartre, c'était, je m'en souviens bien, il y a plus de seize ans; je devais laver l'atelier pour y recevoir ma fille. Le bébé-là est à présent une grande jeune-fille qui fait ses griffes sur le dos tolérant de son père auquel elle mène la vie dure parce qu'il est demeuré, en esprit, aussi enfant qu'il l'était dans le temps où tu l'as connu et tente 'de debrouille' une tête où se chevauchait le meilleur et le pire. Le naturel est revenu au Galot(?), privé du rapport et de l'orientation qui lui était bénéfique [. . . .] Ma femme et moi, prenons ensembles les années. C'est une grande chance que j'ai de les voir passer avec elle.

Je t'embrasse –

(xiv) 25 December 1963, from Mrs Otto L. Spaeth, New York

My dear Mr. Lipchitz:

Otto thought you might be interested in the enclosed. I also want to tell you that Arthur Schlesinger called me when he came home for the Holidays from Washington. You will remember that he has been the Late President's advisor from the beginning of his term. Mr. Schlesinger said he called at the specific request of mrs. Kennedy. She wanted you, and us, to know that she is excited by the idea and said she could think of no one she would rather have do the head of the President. She does understand that it is to be done only if you feel the project will come off the way you want it to. She called Mr. Schlesinger as she left for Florida to tell him she was sorry that with moving, buying a house and getting the children ready for Florida and their christmas that she had not had time to write more than letters to Heads of State (since the tragedy).

We have been asking our newspaper friends and trying to find a lead as to someone who resembles the president but so far have had no luck. This enclosure worries us a little because we feel that if your portrait head does come through, the Capitol would be one of the logical places for the portrait. We hate to see a second rate sculptor get in there.

It is Christmas morning and we are off to the country for a gathering of

the Spaeth clan including twelve grand-children under ten years of age. It will not be a quiet day but I can't wait for it to start.

All good wishes to you and yours,

Affectionately –

(xv) 20 November 1967, from the Mayor of Jerusalem, Teddy Kollek

Dear Jacques,

My visit yesterday did more for me than anything else on my entire trip. It had the hallmark of great humanity and with it a profound sense of time and tradition. I see you as an extraordinary oasis and was thrilled that in my frenetic trip this year I was able to visit even so briefly.

I will be writing to you from Jerusalem. I look forward to hearing from you regarding the date of your brother's visit. I know that Karl will be in touch regarding the medal which is a masterpiece. He also will be writing as will Elaine about [. . .] the Ha'aretz Museum and Elaine will be in touch with you regarding the help that you want to give to the Nechushitan Museum.

My best to Yulla and Lolya,

Yours –

(xvi) 28 November 1967. The Director of Vincent G. Kling Associates writes to Dr. Courtney C. Smith, president of Swarthmore College, Pennsylvania, following a visit by Lipchitz to inspect the plaza for which he was designing *Government of the People*. Lipchitz had been very satisfied with the architectural backdrop for his work.

[. . .] I was thrilled to have this reaction from one whom I consider as do most of the contemporary architects and sculptors today, the greatest living sculptor with a demonstrated ability to perform at the Herculean scale of the outdoors.

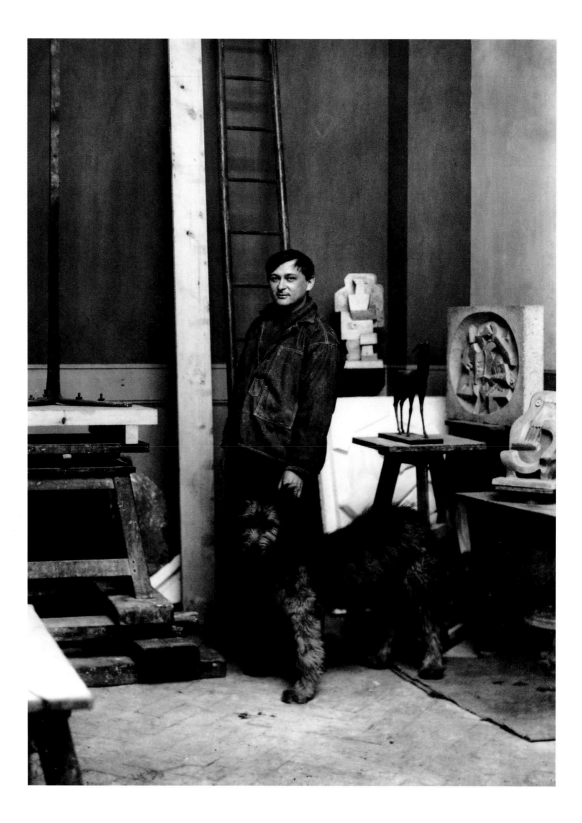

Jacques Lipchitz – a Chronology

The text for the years 1891 to 1958 is a draft compiled by Lipchitz's friend, the critic Waldemar George. It was sent to Lipchitz for possible future use, and signed off as *"bon"* by the sculptor.

1891	Born on August 22 at Druskieniki [Lithuania]. The eldest of 6 children. Son of Abraham Lipchitz and Rachel-Leah Krynsky. The father manages public building projects.
1892–1902	Grows up in the paternal home surrounded by a large garden; Druskieniki is a village dominated by water (in Lithuanian Druskos means salt), situated on the Niemen river beside a large forest. As a child Lipchitz is intelligent, thoughtful, and gifted with a vivid imagination. He enjoys playing with clay and sculpting. He is particularly close to his mother, who is sure of her son's prospects for an outstanding future.
1902–09	After primary school Lipchitz joins the technical college at Bialystok. The pogrom of 1906 prompts his parents to move him to a secondary school in Vilnius. Lipchitz's father wants his son to study engineering, and is set against any career in the arts. Having obtained his school-leaving diploma in 1909, Lipchitz decides to go to Paris, against his father's wishes but with the support of his mother.
1909–10	Arrives in Paris in October. He attends Jean-Antoine Injalbert's atelier at the École des Beaux-Arts as a day student. His father accepts his son's decision and contributes generously to Lipchitz's living expenses. Lipchitz lives at the Hôtel des Mines on the Boulevard St-Germain. Realising that he is not learning as much as he should be at Injalbert's, he leaves his studio to work in a small direct-carving studio. During the winter he enrolls at the Académie Julien, in Raoul Verlet's sculpture class. He is awarded a first prize and a medal. He spends his evenings drawing at the Académie Collarossi and at the Municipal College on the Boulevard Montparnasse. Takes Dr Richet's anatomy course for two years at the École des Beaux-Arts. Lipchitz frequents the Louvre, and spends many hours in contemporary art galleries. He studies the history of art and is particularly interested in primitive art. His preferences lie with the arts of archaic Greece, Egypt, Rome and the Gothic. He becomes a passionate collector.
1911	His family experience financial difficulties that drastically cut Lipchitz's resources. He has to work part-time. A friend, Bernard Szeps, helps him out. Lipchitz falls seriously ill with tuberculosis. He is admitted to hospital and then spends a period of convalescence in Belgium. On his return to Paris he moves to 51 rue de Montparnasse with

90. Jacques Lipchitz in his studio at Montparnasse, 1925
Photograph by Marc Vaux

a friend, a fellow student, Césare Sofianopolo. Lipchitz makes
his portrait.

1912 Lipchitz returns to Russia to do his military service. He is discharged
owing to poor health and in the autumn returns to Paris, where he
rents a studio at 54 rue de Montparnasse.

1913 Befriends the painter Diego Rivera, who introduces him to Picasso.
At first Lipchitz is very resistant to Cubism and in particular to Picasso's
sculptural practice. Lipchitz presents his *Woman and gazelles* at the
Salon d'Automne.

1914 Lipchitz travels to Majorca with friends. From here he journeys to
Madrid, where his *Sailor and guitar* is conceived. In this work Lipchitz
finds a style that is more finely balanced and more radical.

1916 Becomes a friend of Juan Gris. Signs a contract with Léonce
Rosenberg's gallery.

1918 Lipchitz is close to [the poet] Max Jacob, [the writer] Raymond
Radiguet, Jean Cocteau, Modigliani He spends the summer at
Beaulieu-sur-Loches with Juan Gris and other friends.

1920 Has his first solo exhibition at Rosenberg's gallery. Not long after he
terminates his contract with the gallery and buys back all his sculptures.
In May Maurice Raynal publishes a monograph on Lipchitz, whose
reputation is starting to grow. Lipchitz's sculptures are frequently
cited and reproduced in the art press internationally.

1922 Albert Barnes buys several sculptures from him and commissions five
important reliefs for the Barnes Foundation in Merion, Pennsylvania.

1924–25 Lipchitz becomes a French citizen. He marries [the poet] Berthe
Kitrosser and moves to Boulogne-sur-Seine. He researches ways of
producing transparent sculpture. Towards the end of the year he begins
to develop a new method of casting, using models made of fine strands
of wax. He is finally successful and names the product of this new
process his 'transparents'.

1925–26 The series of *Transparents*.

1927 Works on a commission from Charles de Noailles for the gardens of
his property in Hyères [southern France], *The joy of life*, Lipchitz's first
sizeable open-air composition.

1928 Lipchitz is deeply distressed by the deaths of his father and his sister
Genia. The sculptor produces new work for [the couturier] Jacques
Doucet's home at Auteuil: a stone mantelpiece and two gilded firedogs.

He also produces his *Reclining woman and guitar* for Mme de Mandrot's garden in Le Pradet.

1930 Lipchitz's first major retrospective, '100 sculptures by Jacques Lipchitz', at Jeanne Bucher's Galerie de la Renaissance in Paris

1931 Further important work produced as part of the commission from Mme de Mandrot, *The Song of the vowels* (this sculpture was finished in 1932 and was acquired by the Kunsthaus, Zürich).

1934 Death of Lipchitz's mother.

1935 Lipchitz's first significant exhibition in America, at the Brummer Gallery in New York.

1936–37 Lipchitz wins a gold medal for *Prometheus strangling the Vulture*, commissioned for the Palais de la Découverte [the science pavilion] on the occasion of the Paris World Fair. An entire room is dedicated to his work at the Petit Palais within the context of the exhibition 'The Masters of Independent Art'.

1939–40 During these turbulent years Lipchitz draws frequently and sculpts less. He leaves Paris in 1940 and moves to Toulouse, where he executes a number of portraits.

1941 On the invitation of a number of influential American friends (including Alfred Barr) Lipchitz leaves France for New York, where he moves to 42 Washington Square. [His wife Berthe remains in France.]

1942 Lipchitz has his first Buchholz Gallery show. He rents a studio at 2 East 23rd Street.

1943 Has his second show at the Buchholz Gallery. Works on a monumental sculpture for the Ministry of Education Building in Rio de Janeiro on the *Prometheus* theme, continued through 1944.

1946 Third exhibition at the Buchholz Gallery. He makes his first trip back to Paris, where an important exhibition of his work opens at the Galerie Maeght. Receives a commission from a priest, Father Couturier, for the baptismal font of a church in Assy, Haute-Savoie, on the subject that will become *The Virgin of Liesse*. Lipchitz decides to return permanently to America [and to end his marriage to Berthe].

1947 Lipchitz is made Chevalier de la Légion d'Honneur. He moves to Hastings-on-Hudson.

1948 Marries Yulla Halberstadt. Their daughter Lolya Rachel is born. Works on the Assy *Virgin*. Buchholz Gallery exhibition.

1950	Makes a series of studies on the subject of the *Birth of the Muses*, creating a large bas-relief version for Mrs John D. Rockefeller III. Lipchitz has exhibitions of his work at the Portland Museum, the San Francisco Museum and Cincinnati Art Museum. An exhibition of his drawings is mounted at the Galerie du Séminaire in Brussels.
1951	Executes the large-scale model of the Assy *Virgin*. Receives an important commission for the Fairmont Park Association, Philadelphia. Exhibition at the Buchholz Gallery. Touring exhibition on the theme of *The Birth of the Muses*, organized by the Museum of Modern Art, New York.
1952	On 5 January a fire engulfs his studio on 23rd Street, destroying almost everything, including the Assy *Virgin* and his work for Philadelphia. A rehabilitation committee is formed (led by Alfred Barr), which finances the construction of a new studio in Hastings. During its construction Lipchitz continues to sculpt at a temporary studio at the Modern Art Foundry, Long Island City. Here he makes his series *Variations on a Chisel*, as well as several portraits. He exhibits twenty-two sculptures at the 26th Venice Biennale. He also exhibits at Beverly Hills, the Franc Perls Gallery (California) and the Santa Barbara Museum.
1953	In May he moves to his new studio in Hastings. He begins working again on the Assy commission (finally completed in 1955) and also makes new maquettes for *The Spirit of Enterprise* commission for Fairmont Park, Philadelphia. Prepares for his forthcoming Museum of Modern Art retrospective.
1954	A major MoMA retrospective, in co-operation with the Walker Art Center, Minneapolis, and the Cleveland Museum of Art
1955–56	*The cradle, Inspiration,* a series of portraits, and the *Semi-automatics.* He takes up work again on one or two sculptures that were salvaged from the studio fire: *Mother and child, Hagar, Sacrifice.*
1957	Cincinnati exhibition. Shows also at Fine Arts Associates, New York, and the Franc Perls Gallery. Prepares for his retrospective exhibition at the Stedelijk Museum, Amsterdam.
1958	Receives the Creative Arts Award from Brandeis University. A major European travelling show starting in March at the Stedelijk Museum, where 116 works are shown. Creates the *To the Limit of the Possible* series. Lipchitz becomes an American citizen.
[1961–62	Lipchitz begins to be represented by the Otto Gerson Gallery, New York (later Marlborough-Gerson and presently Marlborough Gallery, Inc.). He visits Italy and begins working at the Tommasi Foundry, Pietrasanta, near Carrara's famous marble quarries.

91. Jacques Lipchitz in the 1960s

1963	First visit to Israel. He has an extensive touring exhibition in America.
1964	The Phillips Collection, Washington, D.C., mount an exhibition of his cubist sculpture and reliefs. President Lyndon Johnson commissions Lipchitz to design a medallion for the Presidential Scholar Awards.
1965	Receives an award for cultural achievement from Boston University. His portrait of President John F. Kennedy is installed in Military Park, Newark, New Jersey, and International Students House, Marylebone, London.
1966	Awarded a gold medal by the Academy of Arts and Letters, New York.
1969	He receives the Einstein Award of Merit from the Medical Center of Yeshiva University, New York, and a Medal of Achievement from the American Institute of Architects.
1970–72	Major retrospective exhibitions in Germany, Austria and Israel. One exhibition inaugurates the new Tel Aviv Museum, while the Israel Museum, Jerusalem, celebrates the gift of 130 of Lipchitz's bronze sketches. He works extensively on the important monumental commissions *Bellerophon taming Pegasus* for the Columbia Law School, *The Government of the People* for Philadelphia, and *Our Tree of Life* for Mount Scopus, Jerusalem.
1972	Major exhibition of his work at the Metropolitan Museum of Art, New York, coinciding with the publication of his autobiography, *My Life in Sculpture*.
1973	Lipchitz dies on 26 May on the island of Capri. He is buried in Jerusalem. His will stipulates that none of the extant plaster or terracotta models is to be cast after his death. Instead these are to become the property of the Jacques and Yulla Lipchitz Foundation for distribution to worthy institutions throughout the world.]

Bibliography

UNPUBLISHED MATERIAL

1. Tate Archive, London
Includes hundreds of personal letters, mostly in French, important notebooks and photographs. This is the most significant source of archival material on the sculptor.

2. Deborah Stott Archive, Tate, London (inv. no. 875)
Interview transcripts from 185 interviews given by Lipchitz to Stott in Pietrasanta, Italy, between 1968 and 1970

3. Documentation, Centre Georges Pompidou, MNAM-CCI, Paris
Includes Lipchitz correspondence from 1924 to 1949 and between Lipchitz and his first dealer, Léonce Rosenberg, from 1916 to 1920. The Photothèque also has the original glass plates for photographs of Lipchitz's sculptures taken by the prominent Parisian photographer Marc Vaux.

4. Musée d'Art et d'Histoire du Judaïsme, Paris
Holds some photographs and important correspondence with, amongst others, Albert Barnes and Christian Zervos.

5. Musée du Grand Orient de France, Paris
Holds freemasons' membership records for Lipchitz and Juan Gris.

6. Martine Franck, *Sculpture et Cubisme: 1907–1915*, École du Louvre thesis, Paris, *ca.* 1966; Patrick Daniel Elliott, *Sculpture in France 1918–1939*, doctoral thesis, Courtauld Institute of Art, University of London, 1991; Sophie Bowness, *The Presence of the Past: Art in France in the 1930s*, doctoral thesis, Courtauld Institute of Art, University of London, 1996.

PUBLISHED MATERIAL

A detailed bibliography on Lipchitz is provided in Alan G. Wilkinson, *The Sculpture of Jacques Lipchitz, A Catalogue Raisonné, Volumes One/ Two*, London and New York (Thames & Hudson) 1996/2000. A useful guide to the most recent writing on the artist appears in the bibliography of the latest major exhibition catalogue devoted to Lipchitz, *Lipchitz and the Avant-Garde, From Paris to New York*, Krannert Art Museum, University of Illinois at Urbana-Champaign, 2001.

Further material by the present author on Lipchitz includes:

'Letters to a reconstructed Cubist', *The Sculpture Journal*, v, 2001
'An early sculpture by Jacques Lipchitz', *Burlington Magazine*, no. 1173, December 2000, pp. 777–79

'Lipchitz Maquettes 1928–1942', in *Essays in the Study of Sculpture*, Henry Moore Institute, Leeds, March 1999

'A new perspective on Jacques Lipchitz', in *Jacques Lipchitz,* exhibition catalogue, Museo Reina Sofia, Madrid, May–September 1997, pp. 69, 226ff.

(ed.) *Letters to Lipchitz* (from the Tate Archive), Museo Reina Sofia, Madrid, 1997

Important background reading is listed below:

Bernard Champigneulle, *L'Inquiétude dans l'art d'aujourd'hui*, Paris (Mercure de France) 1939

L'École de Paris 1904–1929, la part de l'Autre, exhibition catalogue, Musée d'art moderne de la Ville de Paris, November 2000– March 2001

Paul Fierens, *Sculpteurs d'aujourd'hui*, Paris (Éditions des Chroniques du Jour) 1933

Pierre Francastel, *Les Sculpteurs célèbres*, Paris (Éditions d'Art Lucien Mazenod) 1954

Malcolm Gee, *Dealers, Critics and Collectors of Modern Painting: Aspects of the Parisian Art Market between 1910 and 1930*, Courtauld Institute of Art doctoral thesis 1977; published by Garland, London and New York

Christopher Green, *Cubism and its Enemies. Modern Movements and Reaction in French Art 1916–1928*, New Haven and London (Yale UP) 1987

Guillaume Janneau, *L'Art cubiste – Théories et réalisations*, Paris (Charles Moreau) 1929

D.-H. Kahnweiler, *Mes galeries et mes peintres*, Paris (Gallimard) 1961

Jacob Katz, *Jews and Freemasons in Europe*, Cambridge MA (Harvard UP) 1970

Alfred Kuhn, *Die Neuere Plastik*, Munich (Delphin Verlag) 1922

Herman Lebovics, *True France. The Wars over Cultural Identity 1900–1945*, Cornell University Press 1992

Pascal Ory, *La Belle Illusion. Culture et politique sous le signe du Front Populaire 1935–1938*, Paris 1994

Maurice Raynal, 'Quelques Intentions du Cubisme', *Le Bulletin de l'Effort Moderne*, Paris, issues 1–3, January–March 1924

André Salmon, *La Jeune Sculpture française*, Paris 1919

Kenneth E. Silver, *Esprit de Corps, The Art of the Parisian Avant-Garde and the First World War, 1914–1925*, London (Thames & Hudson) 1989

Ralph Schor, *L'Opinion française et les étrangers 1919–1939*, Paris (Publications de la Sorbonne) 1985

Eugen Weber, *The Hollow Years*, New York and London (W.W. Norton & Co.) 1994

Ossip Zadkine, *Le Maillet et le ciseau*, Paris (Albin Michel) 1968

Photographic Credits

Every effort has been made to contact the copyright holders of the images used, and the publishers wish to apologise for any omissions. We should be grateful to hear from any individual whose details have inadvertently been omitted, so that this can be rectified in reprinting.

Marlborough Gallery, New York: Frontispiece; 1, 8, 9, 12–14, 16–20, 30, 45, 53–55, 57–63, 65, 67–69, 71, 73–75, 77, 79

Catherine Pütz: 82
Graham Simpson: 11, 21–24, 26, 40, 53, 64, 72, 76
© 2002 Winston E. Theriot: 83–87, 89

Archives du Musée d'Art et d'Histoire du Judaïsme, Paris: 88
Museo Nacional Centro de Arte Reina Sofia Photographic Archive, Madrid: 39
© Photo CNAC/MNAM Dist. RMN: 4, 7
Photothèque, Centre Pompidou, MNAM, Paris: 51
Tate Archive, London: Cover, front and rear flap; 10, 32–34, 43, 56, 91
© Tate, London 2002: 5, 70

Index